WELCOME
to the
DAHLHOUSE

or

Alienation, Incarceration
&
Inebriation in the new
American Rome.

A JOLLY
RUMPUSTIME DIVERSION
for every
Ailing Tot *and*
Mentally Deficient Adult.

Kenneth Dahl, *author*
under license from
MICROCOSM PUBLISHING
Bloomington, Indiana
UNITED STATES OF MURDER, TORTURE &
HI-DEF TV

Welcome to the Dahlhouse: Alienation, Incarceration
& Inebriation in the New American Rome
by Ken Dahl

ISBN 978-1-934620-02-1
This is Microcosm #76064

Distributed in the booktrade by AK Press
sales@akpress.org
510-208-1700

First edition of 3,000 copies published 7/1/8

Microcosm Publishing
222 S. Rogers St.
Bloomington, IN 47404
www.microcosmpublishing.com
812-323-7395

The contents of this book were drawn in Phoenix, AZ; New York, NY;
White River Junction, VT; Portland, OR; and Honolulu, HI.
"Paul" originally appeared in True Porn 2. "Piece by Piece" originally
appeared in Mauled #4. "I Will Die Alone" originally appeared in
Stop Dating. "Time Travel Trip-Up" originally appeared in Sundays #1.
"The Full Stick" and "m4w" were drawn for I Saw You, an anthology
of comics about missed-connections ads on Craigslist.

Thank you, all my friends. Special thanks to Heather Q &
Adventureland.

Ken Dahl draws with the Nikko G nib, eats W.H. Food Home Style
Pierogi, and drinks whatever beer's on sale.

Printed in Canada.

Contents

INTRODUCTION

This book collects a sampling of cartoons that have until now been scattered to the four winds — some self-published over a decade ago, others drawn just last week. Some of them I xeroxed and collated into small booklets that were only read by a couple hundred people. Others were submitted to anthologies. Now, all of them have been mashed together into a convenient sandwich, and I didn't even have to go to Kinko's to do it — which is good timing, as new technologies are making it a lot harder to rip that place off lately.

Looking through the older pages in this book, I have to fight an urge to apologize now — some of them are so quaintly obsolete; relics from a forgotten pre-internet past when "zines" were still a cheap and culturally relevant means of disseminating your opinions, and "DIY" wasn't just a corny home-improvement reference on cable television. I can only hope that those readers who do not remember this simpler, more hopeful era will still consider this new batch of tree-death worth the sacrifice.

A WORD OF CAUTION

Due to spatial constraints, I was unable to include extra pages to clearly separate each story — so in some places it might get hard to tell where one ends and the next begins. To avoid confusion, please make use of the table of contents at the front of this book.

Ken Dahl
Queens, New York
February 2008

Objection, evasion, happy distrust, pleasure in mockery are signs of health: everything unconditional belongs in pathology.

— Nietzsche

"OLD PUNX" VS. COMMODIFICATION

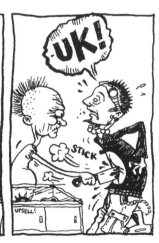

1

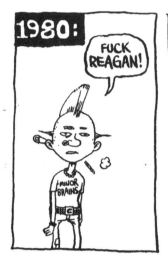

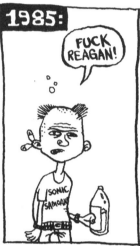

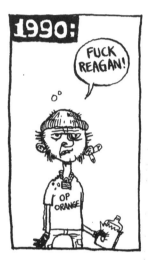

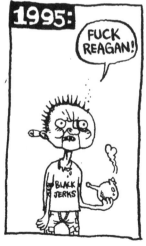

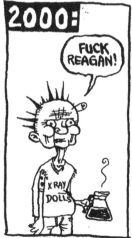

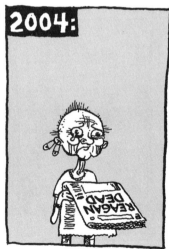

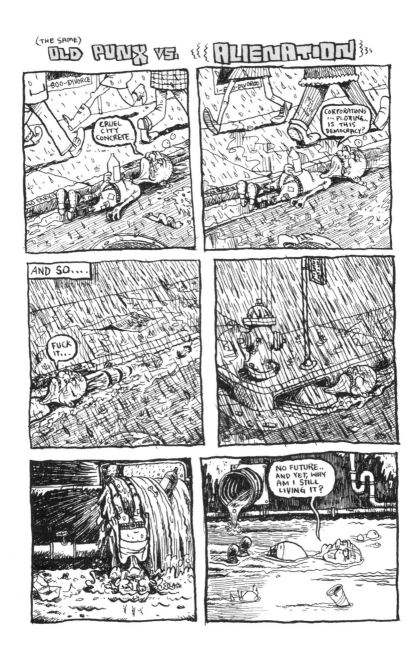

3

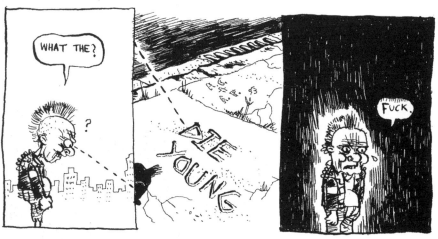

4

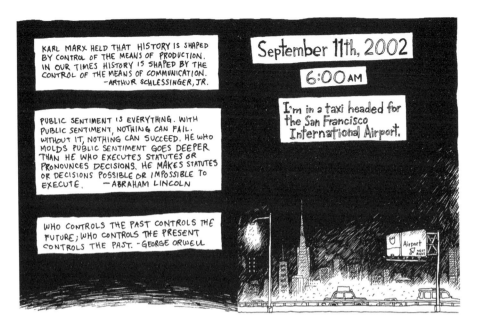

KARL MARX HELD THAT HISTORY IS SHAPED BY CONTROL OF THE MEANS OF PRODUCTION. IN OUR TIMES HISTORY IS SHAPED BY THE CONTROL OF THE MEANS OF COMMUNICATION.
—ARTHUR SCHLESSINGER, JR.

PUBLIC SENTIMENT IS EVERYTHING. WITH PUBLIC SENTIMENT, NOTHING CAN FAIL. WITHOUT IT, NOTHING CAN SUCCEED. HE WHO MOLDS PUBLIC SENTIMENT GOES DEEPER THAN HE WHO EXECUTES STATUTES OR PRONOUNCES DECISIONS. HE MAKES STATUTES OR DECISIONS POSSIBLE OR IMPOSSIBLE TO EXECUTE. —ABRAHAM LINCOLN

WHO CONTROLS THE PAST CONTROLS THE FUTURE; WHO CONTROLS THE PRESENT CONTROLS THE PAST. —GEORGE ORWELL

September 11th, 2002

6:00 AM

I'm in a taxi headed for the San Francisco International Airport.

Airport NEXT RIGHT

The Pentagon has already started broadcasting its day of "America Remembers" agitprop, live from the hole where the plane hit.

♪♪ STAAARS AND STRIPES FOREVERR

OPERATORS LICENSE

As a choir of children bursts into "The Star-Spangled Banner," I realize that the cab driver is singing along... while staring at me through the rearview.

..O'ER THE LAA.. AND OF THE FREEEE

It's funny, what "America Remembers".

America Remembers what it's told to remember. America Remembers insurance companies and stockbrokers. America Remembers cops, soldiers, CIA agents and politicians. America Remembers those freedom-hating, towel-headed, dark-skinned Iraqi terrorist hijackers.

...Or were they Afghan?

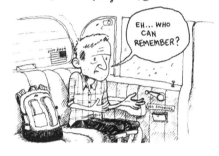

EH... WHO CAN REMEMBER?

And then there's what America forgets.

COINTELPRO; the School of the Americas; the Alien & Sedition Acts; the Espionage Act; the Smith Act; the PATRIOT Acts; Haymarket; the Ludlow Massacre; the Project for the New American Century; "Birth of a Nation"'s White House premiere; Bikini Atoll; the assassination of Fred Hampton; the Cali Cartel; DARPA and its new Total Information Awareness System; the S&L bailout; cops killing black people for trying to vote; John Ashcroft's nephew's pot farm; the agendas of Karl Rove, John Poindexter, Paul Wolfowitz & Dick Cheney; Three-Mile Island; etc., etc., etc., etc., etc., etc...

STOP STOP
CHECKPOINT

NO SMOKING

But who would be stupid enough to remember any of that out loud, on a day like today?

AND WASTE THE WEEKEND IN AN INTERROGATION CELL? FORGET IT.

TICKETING →

UNITED

San Francisco International Airport is a sweatbox of paranoia, patriotism, and conspicuously overarmed SWAT teams.

You could cut the tension with a box cutter.

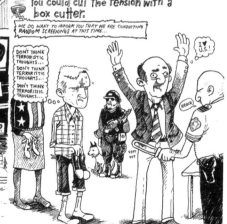

WE DO WANT TO INFORM YOU THAT WE ARE CONDUCTING RANDOM SCREENINGS AT THIS TIME...

DON'T THINK TERRORISTIC THOUGHTS...
DON'T THINK TERRORISTIC THOUGHTS...
DON'T THINK TERRORISTIC THOUGHTS...

I ♥ U.S.!

REACH

Every TV is blaring CNN's coverage of the Pentagon's **Rememberance-fest.**

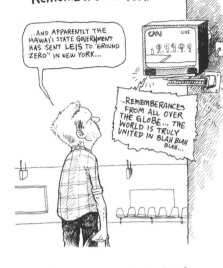

...AND APPARENTLY THE HAWAI'I STATE GOVERNMENT HAS SENT LEIS TO "GROUND ZERO" IN NEW YORK...

...REMEMBERANCES FROM ALL OVER THE GLOBE... THE WORLD IS TRULY UNITED IN BLAH BLAH BLAH...

CNN LIVE

Here comes John Ashcroft, Reminding us that we're living under a Christian military plutocracy.

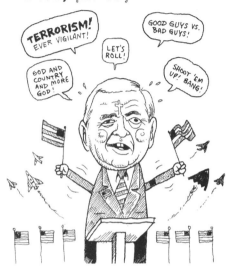

TERRORISM! EVER VIGILANT!

GOOD GUYS VS. BAD GUYS!

LET'S ROLL!

GOD AND COUNTRY AND MORE GOD!

SHOOT 'EM UP! BANG!

Now here's George Bush. *Uniting us against our new Enemies...*

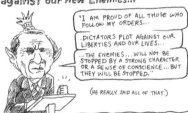

"I AM PROUD OF ALL THOSE WHO FOLLOW MY ORDERS...

...DICTATORS PLOT AGAINST OUR LIBERTIES AND OUR LIVES...

...THE ENEMIES... WILL NOT BE STOPPED BY A STRONG CHARACTER OR A SENSE OF CONSCIENCE... BUT THEY WILL BE STOPPED."

(HE REALLY SAID ALL OF THAT.)

...as the camera pans through the earnest faces of military brass, straining to hold back tough-guy tears.

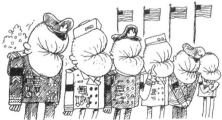

Through all of this, a group of flight attendants at my gate stood together in front of one TV, eerily *at attention.*

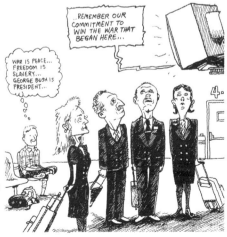

REMEMBER OUR COMMITMENT TO WIN THE WAR THAT BEGAN HERE...

WAR IS PEACE... FREEDOM IS SLAVERY... GEORGE BUSH IS PRESIDENT...

Two 'random' patdowns later, I'm secured into my seat on the plane.

The captain walks down the entire length of both aisles, looking into every one of our faces.

I find myself forcing a smile.

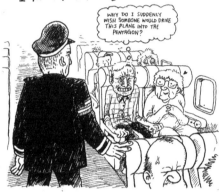

WHY DO I SUDDENLY WISH SOMBONE WOULD DRIVE THIS PLANE INTO THE PENTAGON?

As we taxi down the runway, the captain then says exactly the following over the intercom:

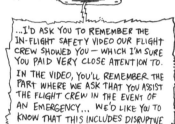

..I'D ASK YOU TO REMEMBER THE IN-FLIGHT SAFETY VIDEO OUR FLIGHT CREW SHOWED YOU — WHICH I'M SURE YOU PAID VERY CLOSE ATTENTION TO.

IN THE VIDEO, YOU'LL REMEMBER THE PART WHERE WE ASK THAT YOU ASSIST THE FLIGHT CREW IN THE EVENT OF AN EMERGENCY... WE'D LIKE YOU TO KNOW THAT THIS INCLUDES DISRUPTIVE BEHAVIOR FROM OTHER PASSENGERS.

I'D LIKE YOU TO THINK ABOUT THAT.

By this time, the entire plane has been whipped into a frenzy of apprehension — causing one woman to literally overdose on Xanax.

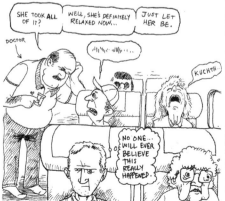

SHE TOOK ALL OF IT?

WELL, SHE'S DEFINITELY RELAXED NOW...

JUST LET HER BE.

DOCTOR

KUCHTH

NO ONE... WILL EVER BELIEVE THIS REALLY HAPPENED.

When it was time for dinner, they announced that there would be only one entree choice: pork chops.

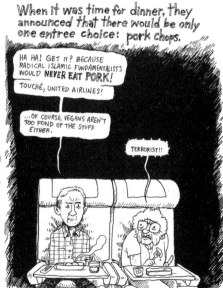

HA HA! GET IT? BECAUSE RADICAL ISLAMIC FUNDAMENTALISTS WOULD **NEVER EAT PORK!**

TOUCHÉ, UNITED AIRLINES!

...OF COURSE, VEGANS AREN'T TOO FOND OF THE STUFF EITHER.

TERRORIST!!

And finally — as if the checkpoints, searches, media psyops, paranoia, war fetishizing, lockstepping xenophobia, food, and jetlag weren't enough to make anyone over five years old disturbed enough to reach for the nearest shoebomb — we then hear this:

LADIES AND GENTLEMEN, THIS IS YOUR CAPTAIN SPEAKING. WE'RE ABOUT TO MAKE PREPARATIONS FOR OUR DESCENT INTO HONOLULU...

BUT BEFORE WE DO, AS IT IS A DAY OF REMEMBERANCE, I'D LIKE US **ALL** TO STAND TOGETHER AND SAY THE **PLEDGE** OF ALLEGIANCE.

And guess what?
Everybody did.

...ONE NATION...
...ÜBER ALLES...

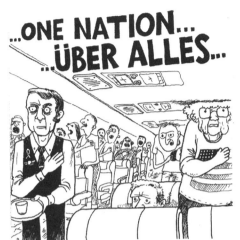

Not that I'm any better... my natural first impulse was to stand up and put hand on heart with the rest of them. I had to memorize the pledge in grade school too. I can go through the motions as well as anyone. I'd prefer to avoid the attention of the Department of Homeland Security as much as the next U.S. citizen.

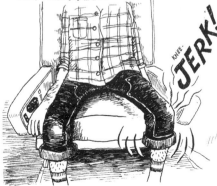

KNEE-
JERK!

But then I thought:

WHY EVEN BOTHER?

Why *bother* pledging allegiance to a flag that's essentially the logo of the Fourth Reich's PR department? Why bother prostrating yourself to a government that extorts your money to fund imperialist wars, stage coups, subsidize global corporations and spread Christian propaganda — but won't even give you the common courtesy of affordable healthcare? What exactly is so righteous about saluting a gaggle of venal, pharisaic, parasitic, warmongering, nuclear-proliferating, deathsquad-training, creation-myth-believing, racist, sexist, homophobic ruling-class vote-pimps in Washington D.C.?

9

But really — why bother? What's in it for us? The shitbags already have not only the *entire globe* but now also *history itself* under their heels... pledging *allegiance* to them is both moot, and proof of our own ever-replenishing capacity for voluntary dehumanization in the face of power — in fact —

Well, actually, all that really happened was, everyone finished and sat back down.

And then the captain said:

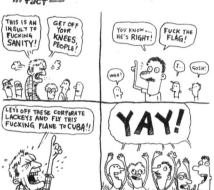

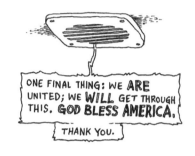

ONE FINAL THING: WE **ARE** UNITED; WE **WILL** GET THROUGH THIS. **GOD BLESS AMERICA.**

THANK YOU.

And then the Xanax lady woke up, right on cue.

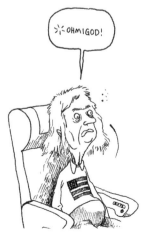

the end.

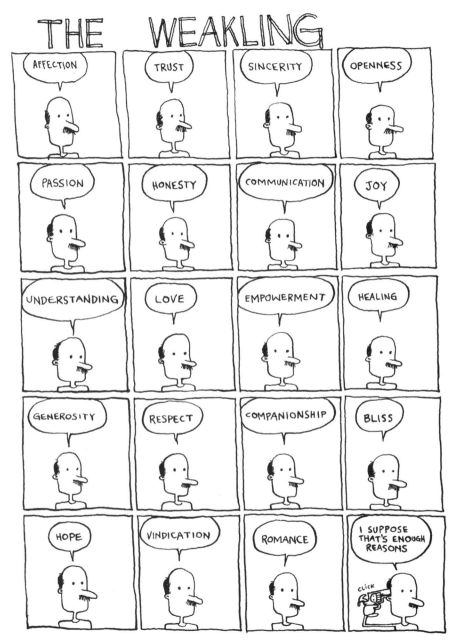

BLIND FART

So there I was, two weeks before the "zine fest."

A washed-up, has-been "alternative cartoonist."

My 31st birthday found me sleepwalking through life as a college-educated line cook,

clocking $7.00 an hour to be the penultimate link in the wending, morbid chain between slaughterhouses, ConAgra Foods™, and the digestive tracts of college students and yuppies.

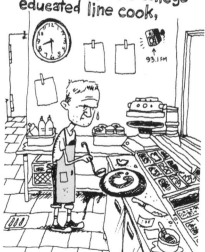

93.1 FM

AND WE USE **CHUCK E. CHEESE** BRAND GROUND BEEF. THE FUCK'S UP WITH THAT??

FREEZER

CHUCK E. CHEESE GROUND BEEF

DON'T CLOCK IN

Meanwhile, things weren't so great on the home front, either.

I had long since abandoned the vain pursuit of "self-publishing."

PLEASE LIKE ME...

...but had also discovered that I lacked any other significant "talents" or interests.

So I took up skateboarding.

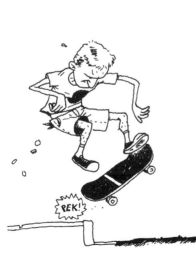

PEK!

That didn't last long.

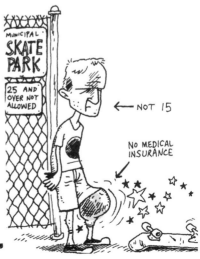

MUNICIPAL SKATE PARK

25 AND OVER NOT ALLOWED

← NOT 15

NO MEDICAL INSURANCE

13

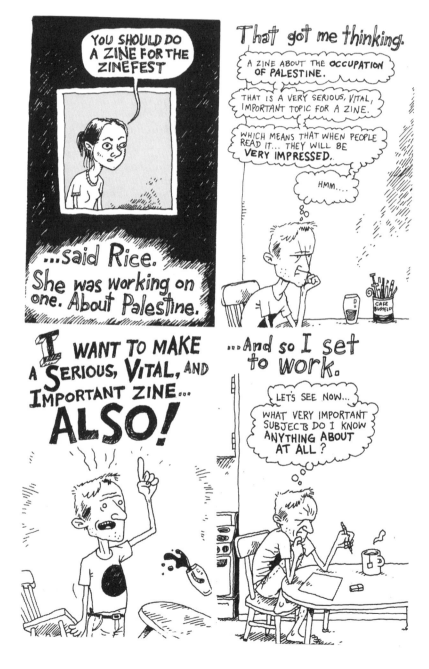

14

And so:

FARTS

A PRIMER

DID YOU KNOW?

FARTS ARE COMPOSED PRIMARILY OF *NITROGEN, CARBON DIOXIDE* (FROM CHEMICAL REACTIONS IN YOUR INTESTINES), AND *HYDROGEN & METHANE* PRODUCED BY YOUR INTESTINAL BACTERIA!

A PERSON FARTS, ON AVERAGE, A HALF-LITER OF GAS PER DAY... ABOUT FOURTEEN FARTS. (I COUNTED LAST WEEK, AND BY BEDTIME HAD COME UP WITH EXACTLY FOURTEEN!)

TERMITES HAVE THE HIGHEST WORLDWIDE OUTPUT OF FARTS OF ANY ANIMAL. THEY PRODUCE AS MUCH METHANE AS ALL THE WORLD'S INDUSTRY, AND ARE A MAJOR CONTRIBUTOR TO GLOBAL WARMING.

SOLDIER TERMITES CAN ALSO TURN THEMSELVES INTO **BOMBS** BY DETONATING THEMSELVES WITH AN EXPLOSIVE RELEASE OF GAS & FECES (A PHENOMENON CALLED "AUTOTHYSIS").

FOODS THAT MAKE YOU FART: BEANS, CORN, BELL PEPPERS, CABBAGE, MILK, & RAISINS.

FOODS THAT MAKE YOUR FARTS STINK: CAULIFLOWER, EGGS, & MEAT. *

*All facts from scientist Brenna Lorenz

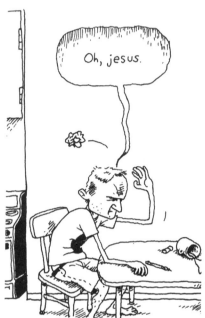

Oh, jesus.

So there I was, three days before the "zine fest."

A washed-up, has-been "alternative cartoonist."

Then:

I NEED SOME TIME ALONE TO FIGURE THINGS OUT

...said Rice.

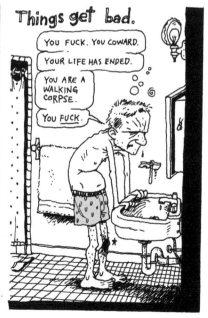

Things get bad.

YOU FUCK. YOU COWARD.

YOUR LIFE HAS ENDED.

YOU ARE A WALKING CORPSE.

YOU FUCK.

Suddenly:
a spurt of inspiration.

I CAN MAKE A ZINE.... **ABOUT MY INABILITY TO MAKE A ZINE!!**

THANK YOU, BEER!!

I KNOW, I KNOW... MALT LIQUOR.

The rest was...
surprisingly easy.

ME

ME ME RICE **ME**

ME ME

ORDER 35

So there I was,
four hours before
the "zine fest"...

THE VERY SAME ZINE YOU ARE NOW HOLDING

17

...swirling down a maelstrom of heartbreak, regret, disease and loneliness...

...a slightly-better-than-has-been "alternative cartoonist."

FLIP

Drawn exclusively at Magoo's and the Mo'ili'ili Zippy's.

END.

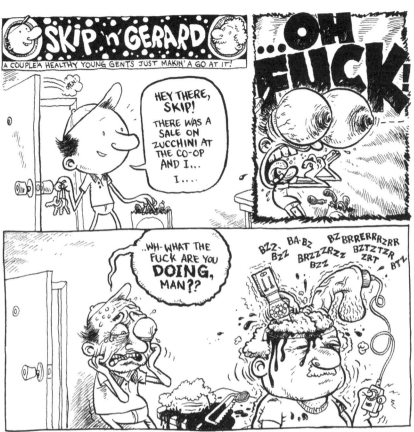

19

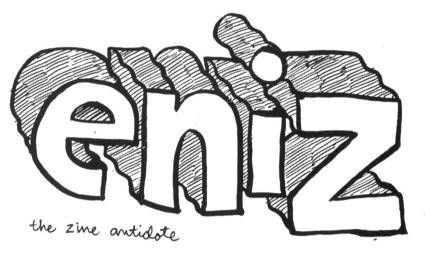

eniz

the zine antidote

by KEN DAHL

THIS CARTOON STORY WAS DRAWN IN JANUARY OF 2000, IN RECOGNITION OF THAT YEAR'S (SPARSELY ATTENDED) HONOLULU "ZINE-FEST."

IT WAS ORIGINALLY PLOTTED AS A LONGER, MORE COMPREHENSIVE POLEMIC AGAINST WHAT WAS VIEWED AT THE TIME AS AN EPIDEMIC OF SELF-ABSORPTION AND LAZINESS AMONG MANY SELF-DESCRIBED "ZINESTERS" APPEARING IN THE WAKE OF POPULAR CULTURE'S AUTOPSY OF THE ZINE MEDIUM, AFTER MOST OF THE TALENT HAD BAILED OUT FOR THE INTERNET.

"ENIZ" ITSELF WAS ABORTED PREMATURELY BY ITS CREATOR FOR REASONS WHICH THE READER WILL SOON FIND SELF-EVIDENT.

21

22

23

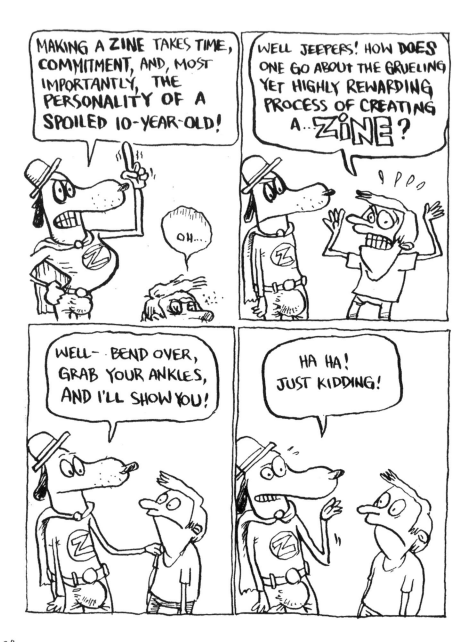

24

A brief HISTORY
...of "zines"

ZINES

THE CULTURAL ANOMALY KNOWN AS THE "ZINE" (PRONOUNCED "sƏy-nüh") ENJOYS A LONG AND COLORFUL HISTORY AS A MEDIUM FOR PLEBIAN EXPRESSION AND COMMUNICATION.

SINCE THE CONCEPTION OF "FANZINES" IN THE 1920'S, ZINES HAVE OFFERED A VOICE AND SENSE OF COMMUNITY TO FRINGE-DWELLING TYPES WHO WOULD OTHERWISE HAVE LITTLE OPPORTUNITY FOR SELF-EXPRESSION. "ZINES" CAN BE EMPOWERING, DIVERGENT, THOUGHT-PROVOKING, AND A LOT OF FUN TO READ. THE 1ST AMENDMENT AT ITS QUIRKIEST!

IN THE 60'S & 70'S, ZINES ENJOYED A NEW POPULARITY AS TOOLS OF OUTSPOKEN REVOLUTIONARIES IN THEIR STRUGGLES AGAINST OPPRESSION, THE ESTABLISHMENT, THE STATUS QUO, AND DISCO.

SINCE THE XEROX REVOLUTION OF THE 80'S, ZINE PRODUCTION HAS SKYROCKETED.... SOME ZINES, LIKE **COMETBUS** AND **BEER FRAME**, HAVE BUILT UP RELATIVELY LARGE PRINT RUNS BY VIRTUE OF RAW TALENT AND ELBOW GREASE ALONE...

...BUT WHAT THE FUCK SHOULD **YOU** CARE ABOUT ALL THAT?

"ZINES" GOT CO-OPTED BY THE MALL CROWD YEARS AGO— ALONG WITH PUNK ROCK, HEROIN, AND ANAL SEX.

"ANAL SEX"?

BECAUSE OF THEIR BRIEF MOMENT IN THE SPOTLIGHT AS "GENERATION X" ACCESSORIES, ZINES IN THE 90'S HAVE BEEN LARGELY REJECTED AND ABANDONED BY THE SAME "COUNTERCULTURE" TYPES THAT ONCE ESPOUSED THEM....

THE SECRET IS OUT, THE JIG IS UP, AND MINDS OF TALENT AND PURPOSE HAVE ALL BUT EVACUATED THE "ZINE WORLD", TOWARDS NEWER, COOLER, LESS CORRUPTED FRONTIERS (OR AT LEAST THE INTERNET).

MEANWHILE, THE SCUM RISES: EAGER TO POUNCE ON THE DECAYING CORPSE OF ZINEDOM, PETTY, FAD-FOLLOWING CULTURAL PARASITES HAVE RECENTLY BEEN SHOVING VACUOUS ZINE-LIKE INCONSEQUENTIA IN OUR FACES FROM EVERY PRETENTIOUS CAFE AND RE-CORD STORE CASHIER DESK IN TOWN, ON A FINAL CRU-SADE TO SUCK THE LAST SPARK OF LIFE FROM THE VEINS OF A ONCE VIBRANT AND VIRILE MEDIUM!

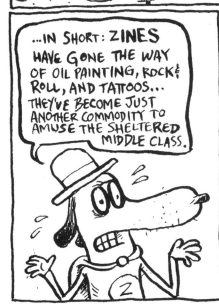

...IN SHORT: ZINES HAVE GONE THE WAY OF OIL PAINTING, ROCK & ROLL, AND TATTOOS... THEY'VE BECOME JUST ANOTHER COMMODITY TO AMUSE THE SHELTERED MIDDLE CLASS.

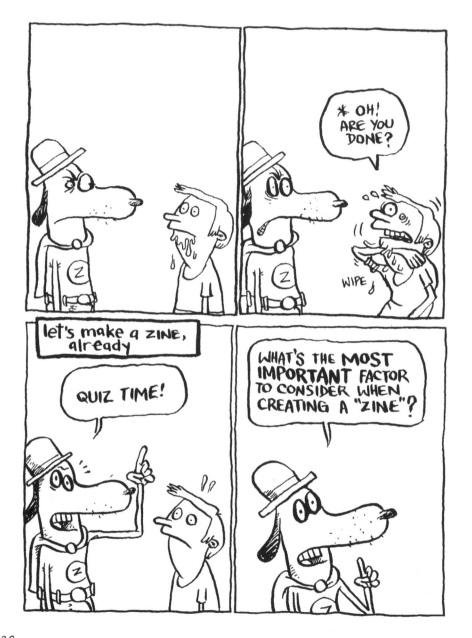

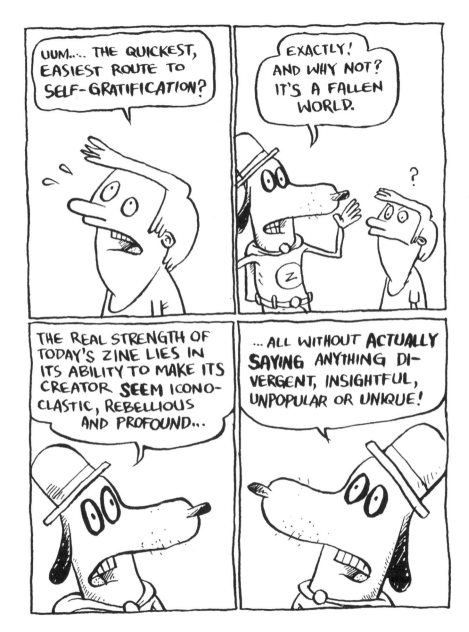

29

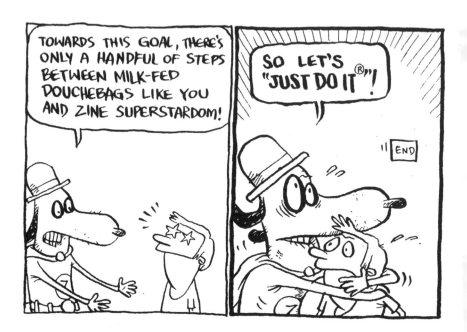

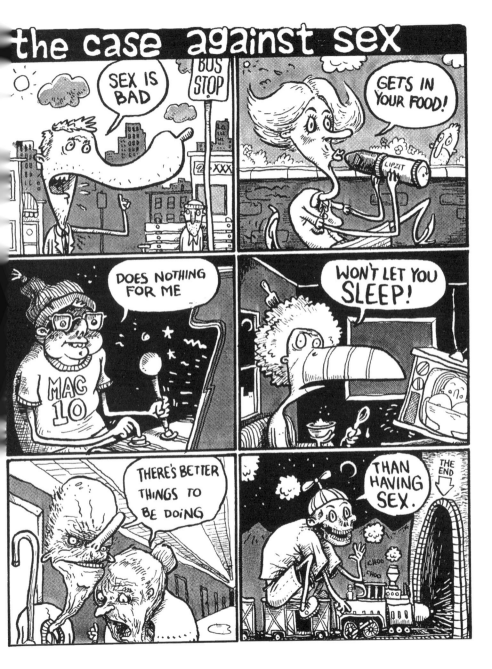

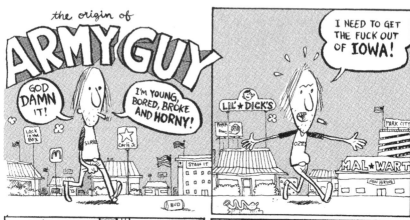

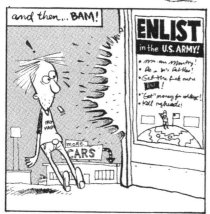

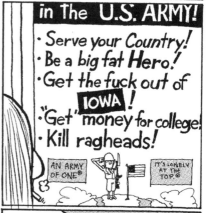

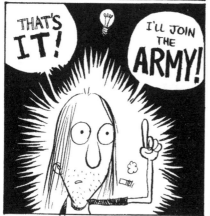

WELCOME...

PING PING

...TO THE U.S. ARMY!!

SON, YOU'RE ABOUT TO EMBARK ON AN **AMAZING** JOURNEY! ONE FILLED WITH ADVENTURE, GLORY, HONOR, AND HORRIBLE DISFIGUREMENT & DEATH... ALL IN THE NAME OF THE **UNITED STATES** OF **AMERICA!**

an ARI of ON

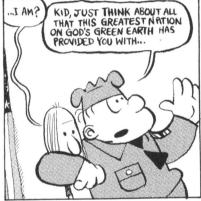

...I AM?

KID, JUST **THINK** ABOUT ALL THAT THIS GREATEST NATION ON GOD'S GREEN EARTH HAS PROVIDED YOU WITH...

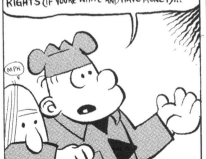

...AN EDUCATION (IF YOU'VE GOT MONEY), HEALTH CARE (IF YOU'VE GOT MONEY), THE PROTECTION OF YOUR FREEDOMS AND BASIC HUMAN RIGHTS (IF YOU'RE WHITE AND HAVE MONEY)...

MPH

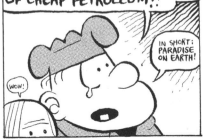

YOU'VE GOT THE WORLD'S WIDEST SELECTION OF **FAST FOODS**, A CONSTANT BARRAGE OF INSTITUTIONALIZED FUNDAMENTALIST CHRISTIAN INDOCTRINATION, FOUR-BY-FOUR PICKUP TRUCKS, WAKEBOARDING ON **DEMAND**, AND A **SEEMINGLY ENDLESS** SUPPLY OF CHEAP PETROLEUM!!

IN SHORT: PARADISE ON EARTH!

WOW!

33

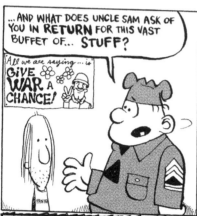

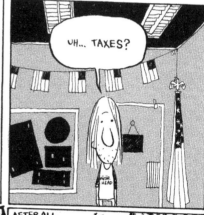

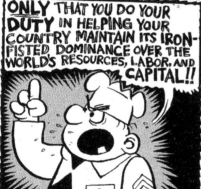

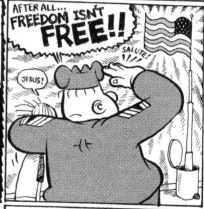

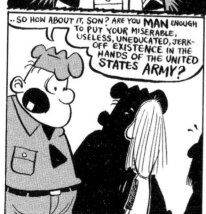

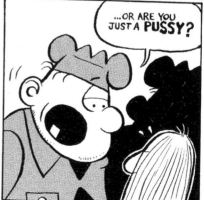

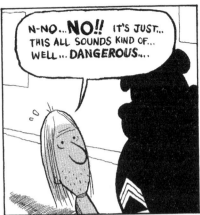

N-N0... **NO!!** IT'S JUST... THIS ALL SOUNDS KIND OF... WELL... DANGEROUS...

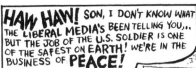

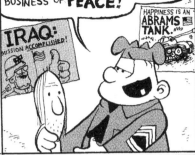

HAW HAW! SON, I DON'T KNOW WHAT THE LIBERAL MEDIA'S BEEN TELLING YOU,.. BUT THE JOB OF THE U.S. SOLDIER IS ONE OF THE SAFEST ON **EARTH!** WE'RE IN THE BUSINESS OF **PEACE!**

IRAQ: MISSION ACCOMPLISHED!

HAPPINESS IS AN **ABRAMS TANK.**

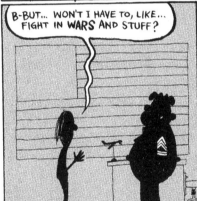

B-BUT... WON'T I HAVE TO, LIKE... FIGHT IN **WARS** AND STUFF?

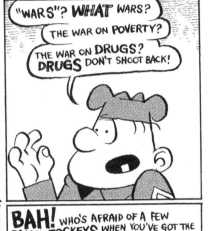

"WARS"? **WHAT** WARS?

THE WAR ON POVERTY?

THE WAR ON **DRUGS? DRUGS** DON'T SHOOT BACK!

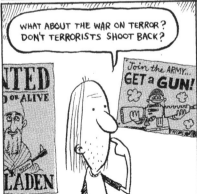

WHAT ABOUT THE WAR ON TERROR? DON'T TERRORISTS SHOOT BACK?

NTED D OR ALIVE

Join the ARMY... GET A **GUN!**

LADEN

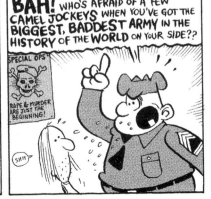

BAH! WHO'S AFRAID OF A FEW CAMEL JOCKEYS WHEN YOU'VE GOT THE **BIGGEST, BADDEST ARMY** IN THE HISTORY OF THE WORLD ON YOUR SIDE??

SPECIAL OPS

RAPE & MURDER ARE JUST THE BEGINNING!

(SHIT)

...BESIDES, MOST OF THE ACTUAL **FIGHTING** IS HANDLED BY ULTRASOPHISTICATED ROBOTS THESE DAYS.

MOSTLY YOUR JOB'LL JUST BE PUSHING BUTTONS, CLEANING SAND OUT OF ENGINES, AND HANDING OUT CANDY TO LITTLE BROWN KIDS!

U-S-A! U-S-A! U-S-A! U-S-A! U-S-A! U-S-A! U-S-A! U-S-A! U-S-A! U-S-A! U-S-A!

BUT... WHAT ABOUT **IRAQ?** DON'T THEY, LIKE... HATE AMERICA AND STUFF?

IRAQ... **RIGHT.**

· President Geor

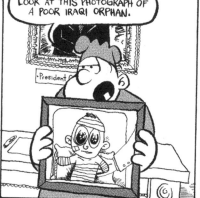

LOOK AT THIS PHOTOGRAPH OF A POOR IRAQI ORPHAN.

· President G

WHEN HIS ENTIRE EXTENDED FAMILY WAS KILLED BY **STATE-OF-THE-ART, HIGH-PRECISION, LASER-GUIDED** DEPLETED-URANIUM BOMBS, **WHO** DO YOU THINK CAME TO HIS RESCUE WITH A COKE, A TEDDY BEAR AND A BIBLE?

UM...

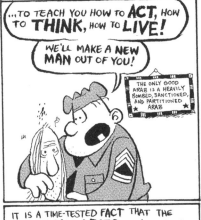

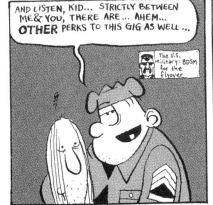

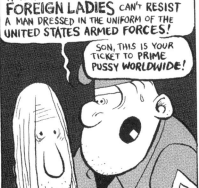

(...ESPECIALLY AFTER WE'VE ELIMINATED THE **COMPETITION** BY BLOWING AWAY ALL THEIR LITTLE **RAGHEAD BOYFRIENDS**!)

I... UH... WELL...

SON... YOU'RE NOT **QUEER**, ARE YOU?

HELL **NO** I AIN'T NO **QUEER**!

WELL THEN, WHAT ARE WE WAITING FOR?

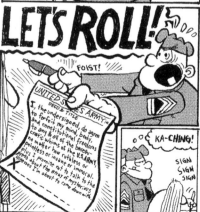

LET'S **ROLL**!

FOIST!

UNITED STATES ARMY

KA-CHING!

SIGN SIGN SIGN

"The West won the world not by the superiority of its ideas or values or religion but rather by its superiority in applying organized violence. Westerners often forget this fact, non-Westerners never do."
—Samuel P. Huntington

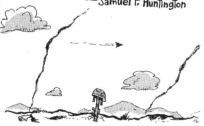

38

PUT FROZEN BANANAS IN YOUR CEREAL

a skillshare by Gordon Smalls

HEM —

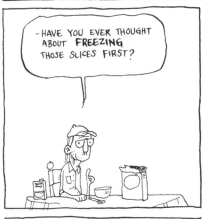

AS COMMONPLACE AS IT MIGHT BE TO ADD BANANAS TO ONE'S CEREAL AT ROOM TEMPERATURE (OR PERHAPS REFRIGERATED)—

—HAVE YOU EVER THOUGHT ABOUT **FREEZING** THOSE SLICES FIRST?

CONSIDER...

PLASTIC CONTAINER OF BANANAS, PEELED, SLICED, AND PLACED IN FREEZER 48 HOURS BEFOREHAND

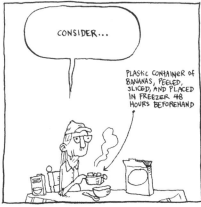

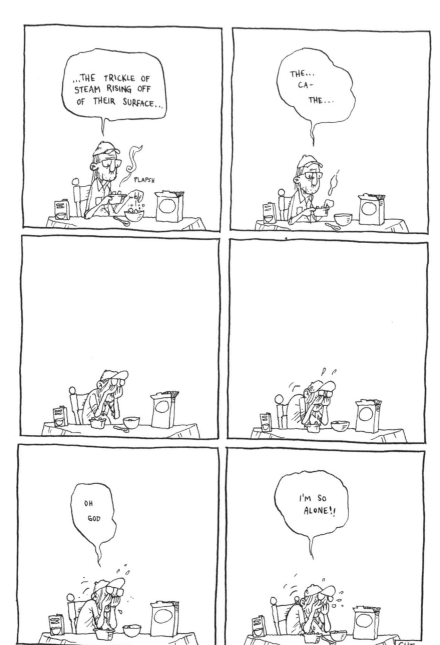

PAUL

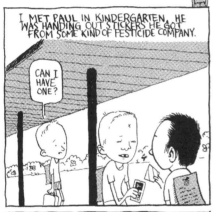

I MET PAUL IN KINDERGARTEN. HE WAS HANDING OUT STICKERS HE GOT FROM SOME KIND OF PESTICIDE COMPANY.

CAN I HAVE ONE?

WE BOTH HAD COWLICKS.

ONCE ME, HIM AND A KID THAT WOULD ONE DAY BECOME A FAMOUS BEACH-VOLLEYBALL PLAYER SNUCK A FIRE EXTINGUISHER BEHIND THE SCHOOL

FOOSH

THROUGH SECOND GRADE WE SPENT RECESS IN A CONCRETE TUBE TALKING ABOUT GIRLS WE WANTED TO "OOF"

DANIELLE SEO

MAILE SERA

41

WEEKENDS WE RODE BIKES TO THE MALL TO SHOPLIFT GUM AND ACTION FIGURES FROM WOOLWORTHS

THE SMELL OF FRIED CHICKEN

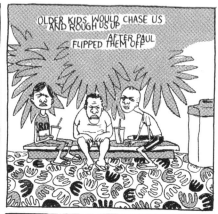

OLDER KIDS WOULD CHASE US AND ROUGH US UP AFTER PAUL FLIPPED THEM OFF

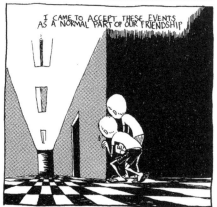

I CAME TO ACCEPT THESE EVENTS AS A NORMAL PART OF OUR FRIENDSHIP

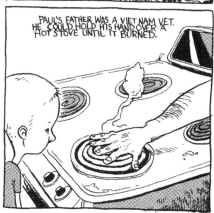

PAUL'S FATHER WAS A VIETNAM VET. HE COULD HOLD HIS HAND OVER A HOT STOVE UNTIL IT BURNED.

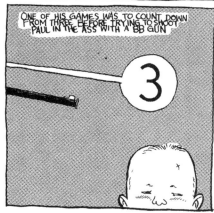

ONE OF HIS GAMES WAS TO COUNT DOWN FROM THREE BEFORE TRYING TO SHOOT PAUL IN THE ASS WITH A BB GUN

3

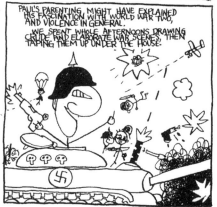

PAUL'S PARENTING MIGHT HAVE EXPLAINED HIS FASCINATION WITH WORLD WAR TWO, AND VIOLENCE IN GENERAL.

WE SPENT WHOLE AFTERNOONS DRAWING CRUDE AND ELABORATE WAR SCENES, THEN TAPING THEM UP UNDER THE HOUSE.

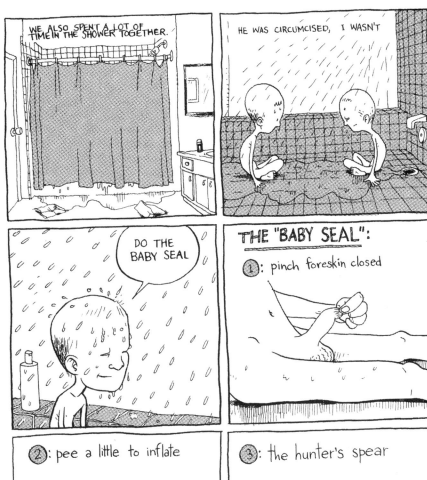

WE ALSO SPENT A LOT OF TIME IN THE SHOWER TOGETHER.

HE WAS CIRCUMCISED, I WASN'T

DO THE BABY SEAL

THE "BABY SEAL":

①: pinch foreskin closed

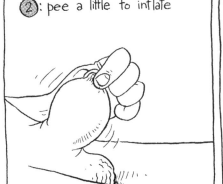

②: pee a little to inflate

③: the hunter's spear

43

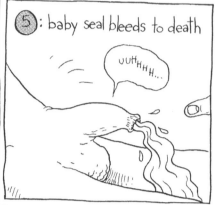

4: Spear the baby seal

POKE

AAAAH!

5: baby seal bleeds to death

UUHHHH...

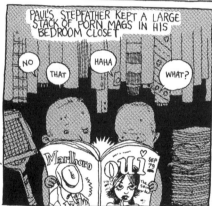

PAUL'S STEPFATHER KEPT A LARGE STACK OF PORN MAGS IN HIS BEDROOM CLOSET

NO

THAT

HAHA

WHAT?

Marlboro

Oui

SEP 79

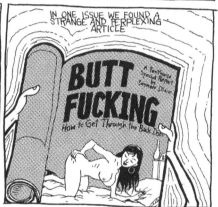

IN ONE ISSUE WE FOUND A STRANGE AND PERPLEXING ARTICLE

BUTT FUCKING

How to Get Through the Back Door

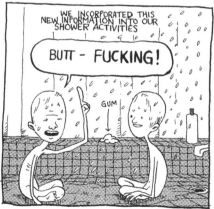

WE INCORPORATED THIS NEW INFORMATION INTO OUR SHOWER ACTIVITIES

BUTT - FUCKING!

GUM

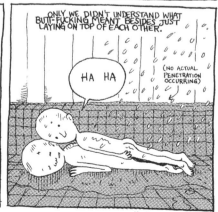

ONLY WE DIDN'T UNDERSTAND WHAT BUTT-FUCKING MEANT BESIDES JUST LAYING ON TOP OF EACH OTHER.

HA HA

(NO ACTUAL PENETRATION OCCURRING)

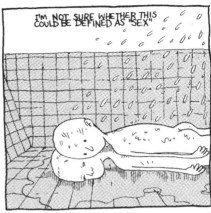

WE'RE DOIN' IT

I'M NOT SURE WHETHER THIS COULD BE DEFINED AS "SEX"

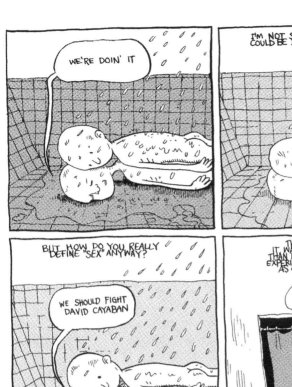

BUT HOW DO YOU REALLY DEFINE "SEX" ANYWAY?

WE SHOULD FIGHT DAVID CAYABAN

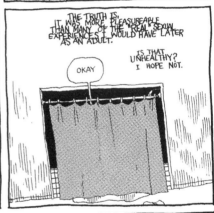

THE TRUTH IS, IT WAS MORE PLEASUREABLE THAN MANY OF THE "REAL" SEXUAL EXPERIENCES I WOULD HAVE LATER AS AN ADULT.

IS THAT UNHEALTHY? I HOPE NOT.

OKAY

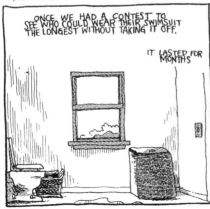

ONCE WE HAD A CONTEST TO SEE WHO COULD WEAR THEIR SWIMSUIT THE LONGEST WITHOUT TAKING IT OFF.

IT LASTED FOR MONTHS

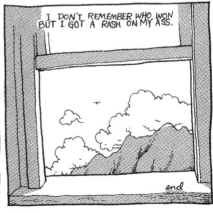

I DON'T REMEMBER WHO WON BUT I GOT A RASH ON MY ASS.

end

45

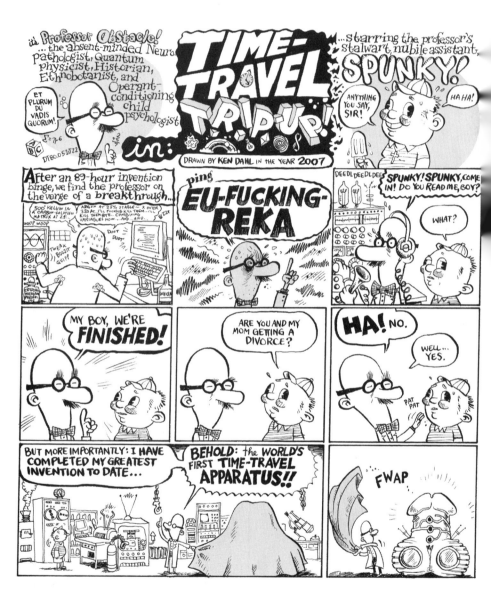

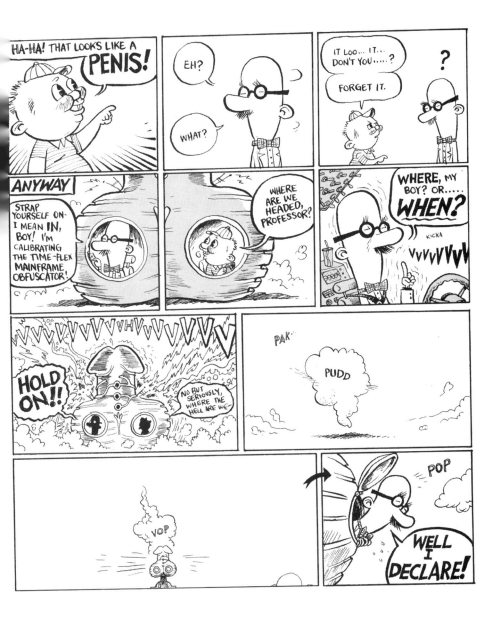

47

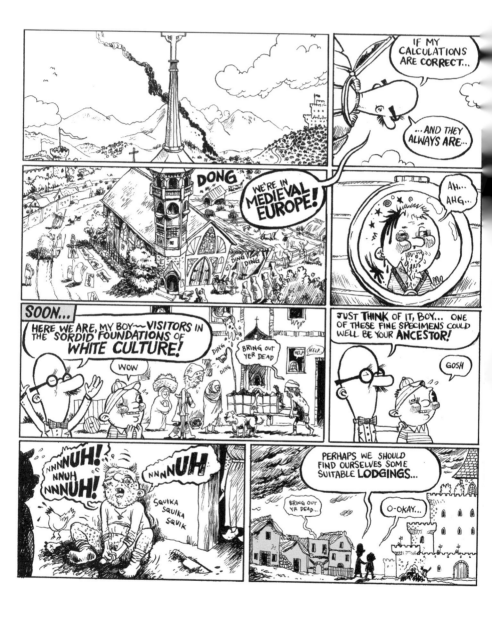

48

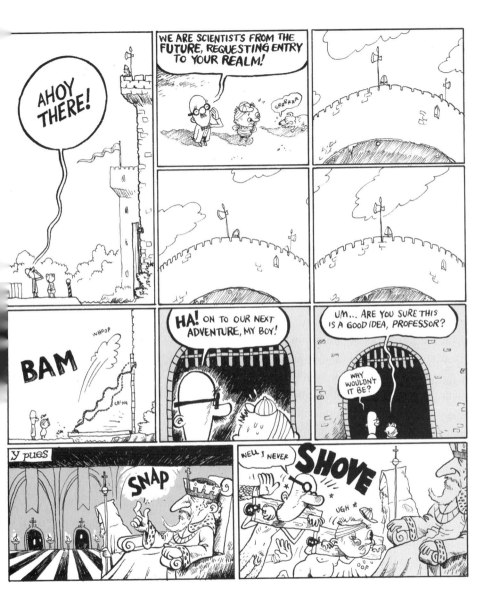

49

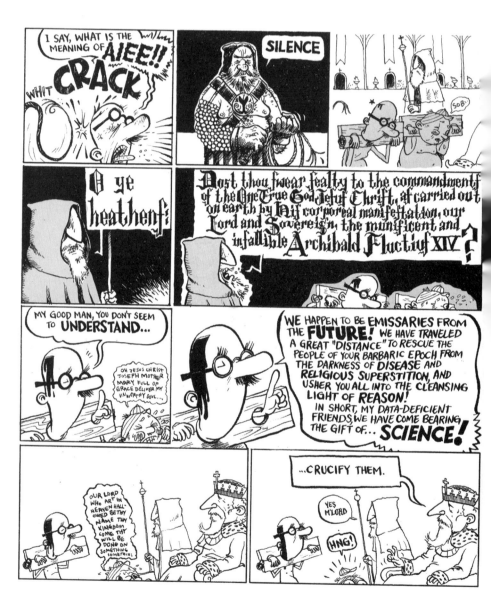

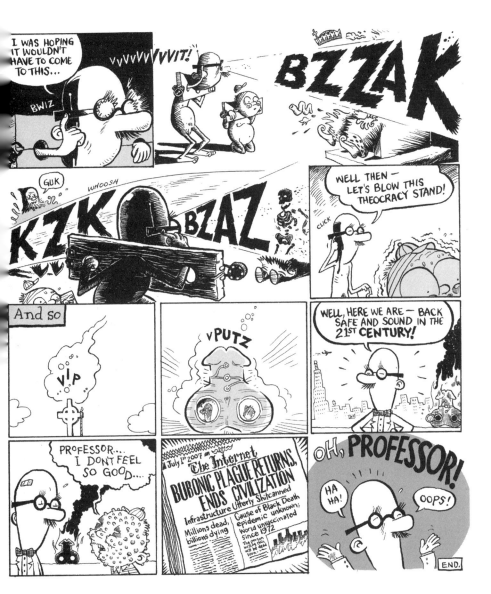

51

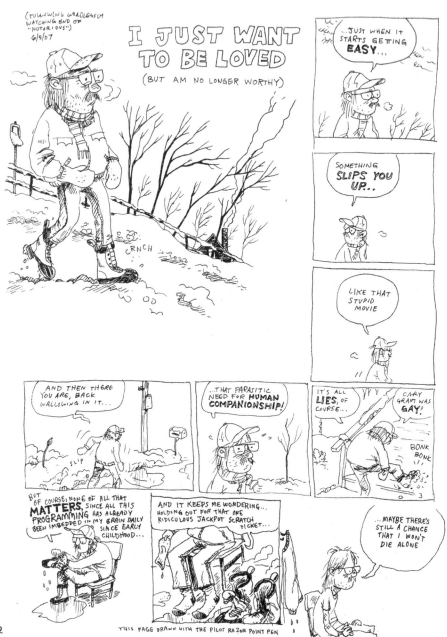

THIS PAGE DRAWN WITH THE PILOT RAZOR POINT PEN

SWING AT NIGHT

with Gordon Smalls

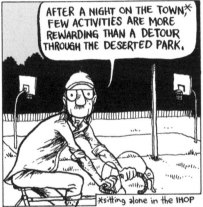

AFTER A NIGHT ON THE TOWN,* FEW ACTIVITIES ARE MORE REWARDING THAN A DETOUR THROUGH THE DESERTED PARK.

*sitting alone in the IHOP

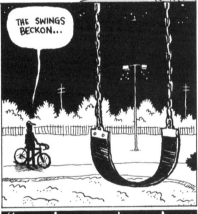

THE SWINGS BECKON...

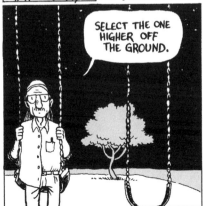

SELECT THE ONE HIGHER OFF THE GROUND.

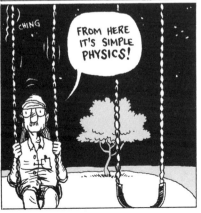

CHING

FROM HERE IT'S SIMPLE PHYSICS!

THE EXHILIRATION OF SIMULATED FLIGHT...

GRINT

GRick ik

...A FACE FULL OF STARS...

GREET

GRRt ik

THE EARTHBOUND WORLD BECOMES DISTANT... INSIGNIFICANT...

GWEET

DREAMLIKE, EVEN...

GRick. ick

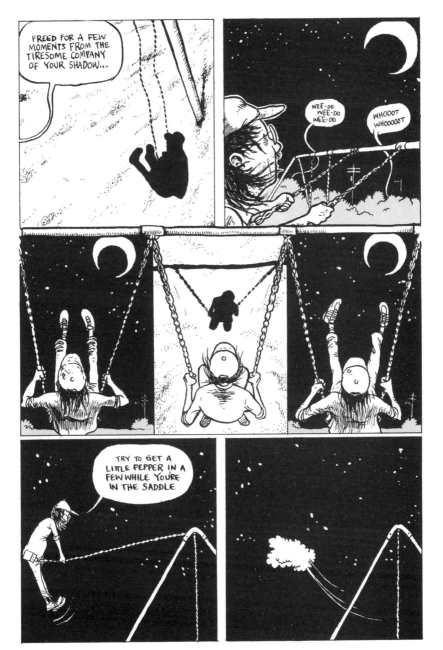

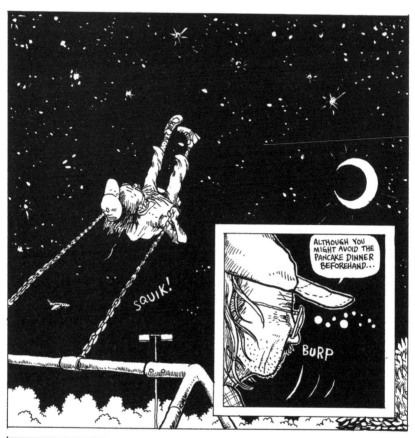

SQUIK!

ALTHOUGH YOU MIGHT AVOID THE PANCAKE DINNER BEFOREHAND...

BURP

SKRP

SKRP

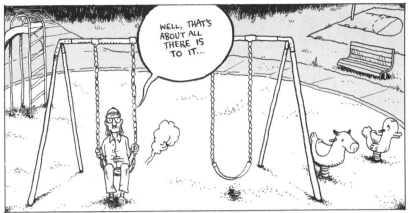

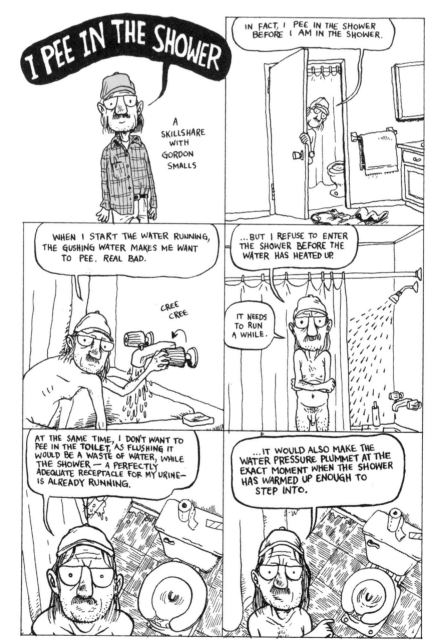

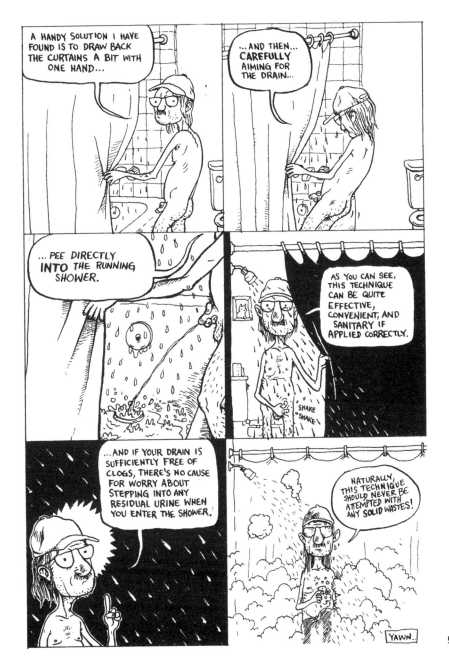

59

How to Steal the Food You Deserve

an important skillshare
by

GORDON SMALLS,

pictured

HELLO.

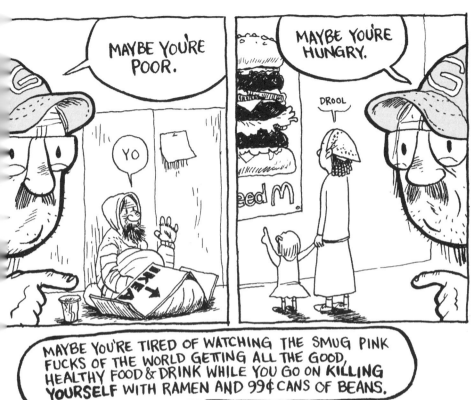

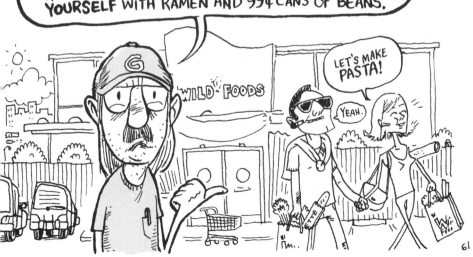

61

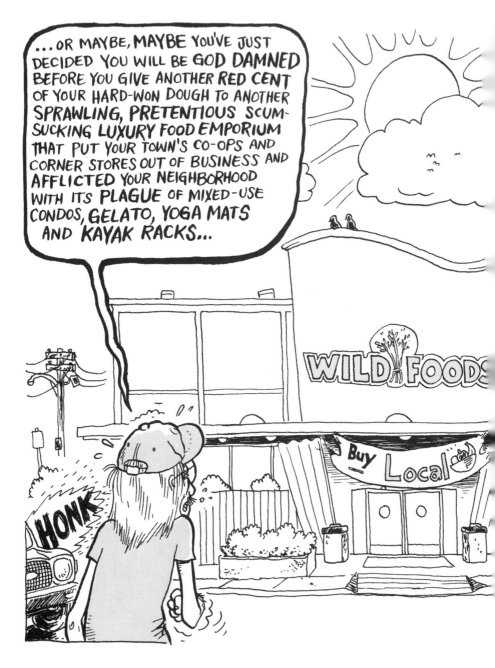

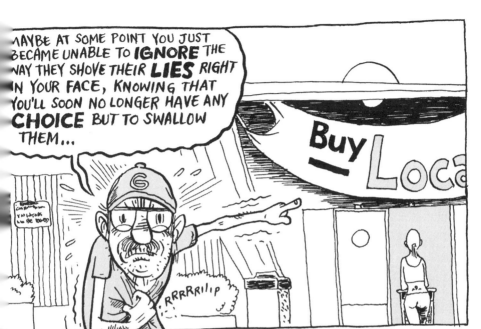

MAYBE AT SOME POINT YOU JUST BECAME UNABLE TO **IGNORE** THE WAY THEY SHOVE THEIR **LIES** RIGHT IN YOUR FACE, KNOWING THAT YOU'LL SOON NO LONGER HAVE ANY **CHOICE** BUT TO SWALLOW THEM...

RRRRRIIIIP

AT THIS POINT, IT BECOMES NOT ONLY YOUR **COSMIC RIGHT** BUT A SOLEMN **MORAL DUTY** TO DO WHAT MUST **BE DONE...**

...AND START GETTING **DOWN** WITH SOME **MOTHER FUCKING CRIME!!**

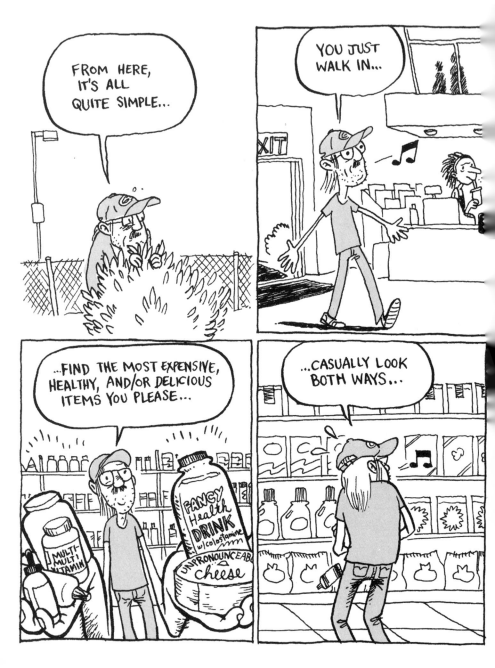

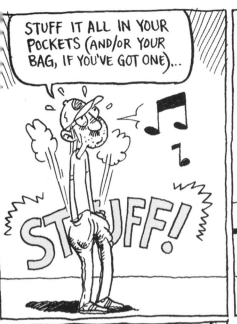

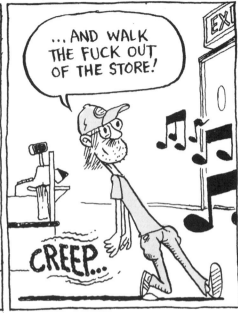

65

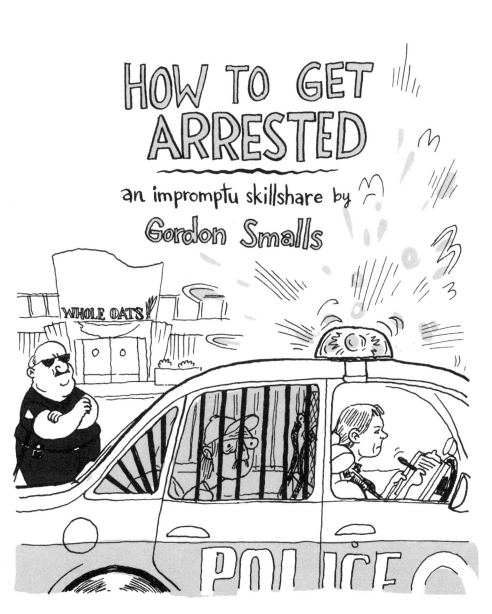

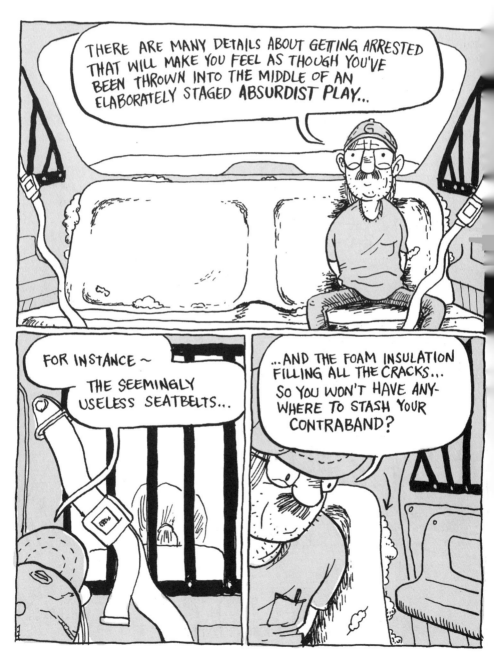

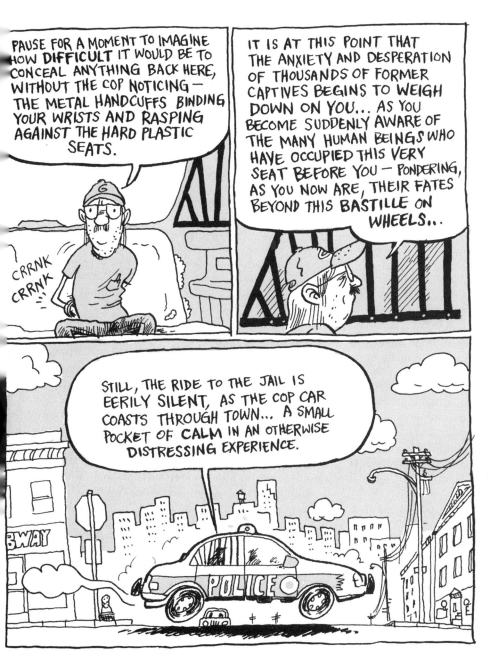

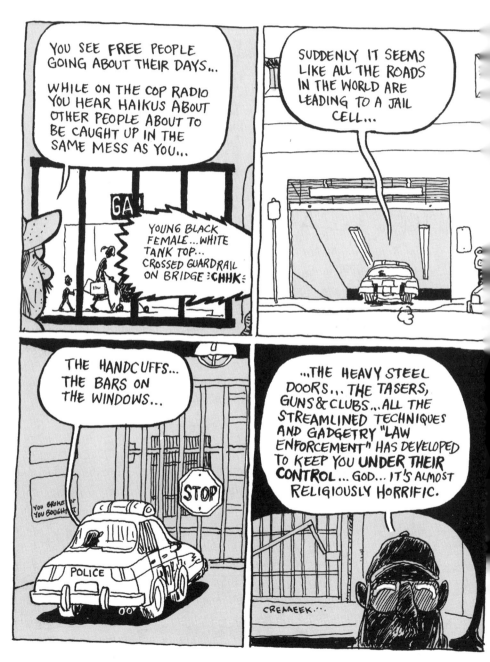

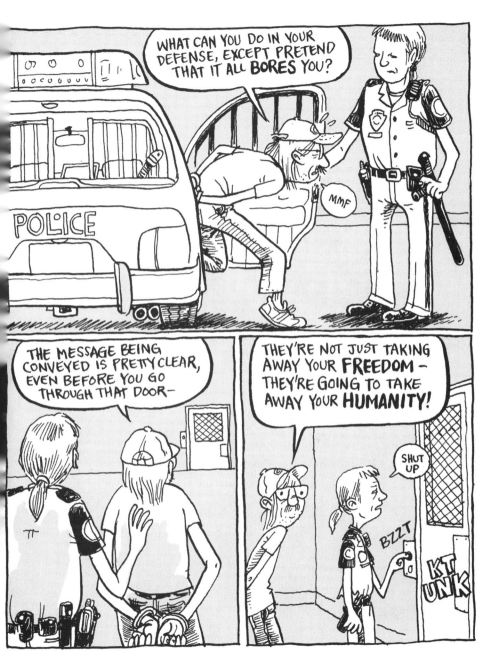

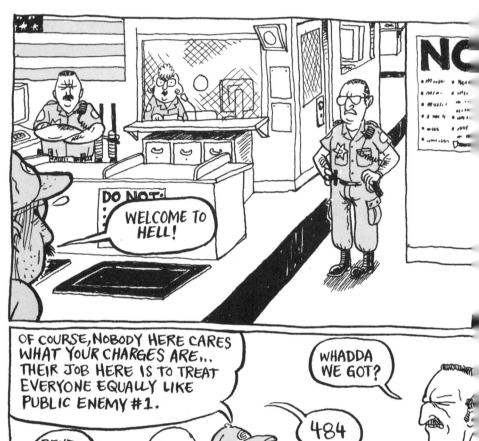

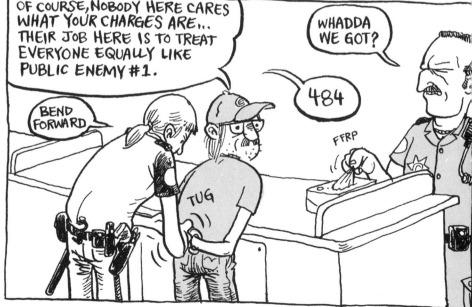

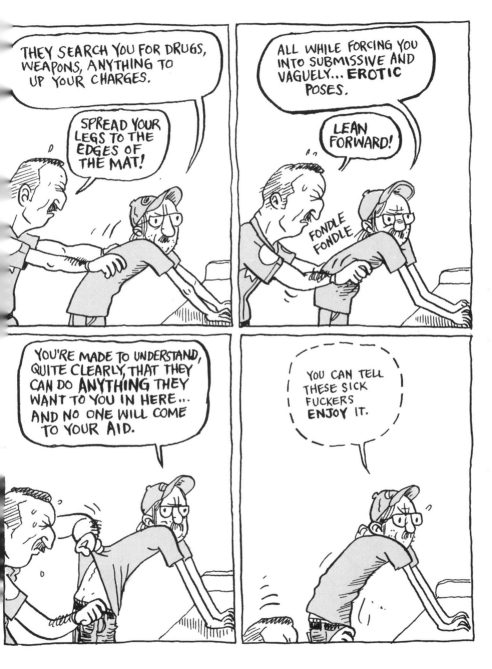

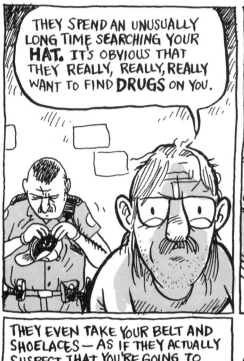

THEY SPEND AN UNUSUALLY LONG TIME SEARCHING YOUR **HAT**. IT'S OBVIOUS THAT THEY REALLY, REALLY, REALLY WANT TO FIND **DRUGS** ON YOU.

EVERYTHING ON YOUR PERSON IS SPREAD OUT ON A TABLE AND SCRUTINIZED.

THEY EVEN TAKE YOUR BELT AND SHOELACES — AS IF THEY ACTUALLY SUSPECT THAT YOU'RE GOING TO **HANG** YOURSELF OVER A CLASS-THREE MISDEMEANOR!

ALL WHILE THEIR PAL **BILL O'REILLY** BLATHERS ON IN THE BACKGROUND ABOUT HOW WELL THE BOMBINGS ARE GOING...

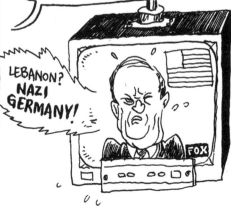

LEBANON? **NAZI GERMANY!**

FOX

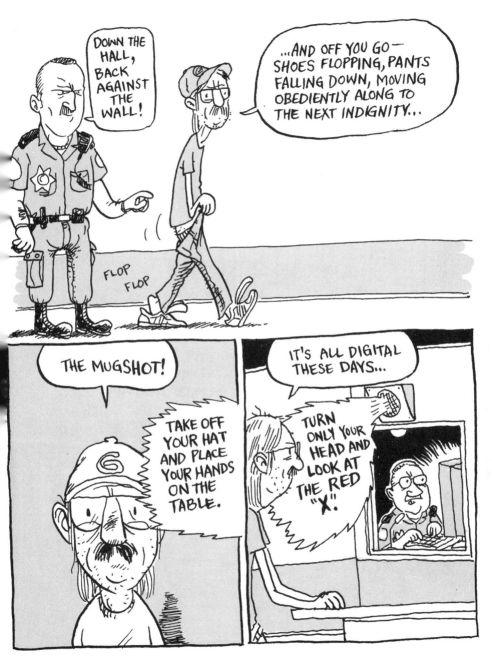

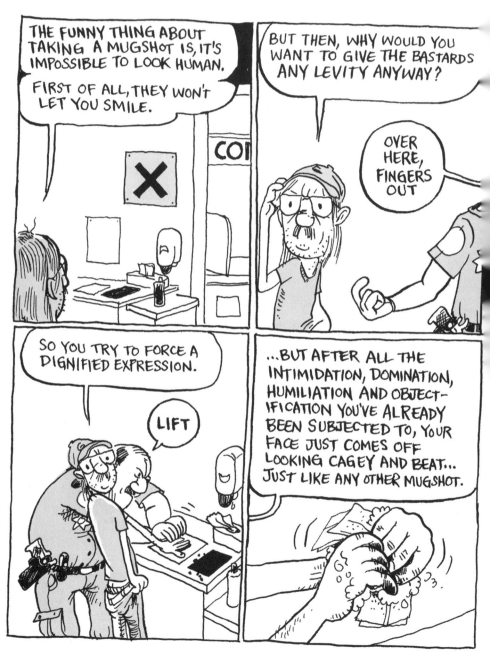

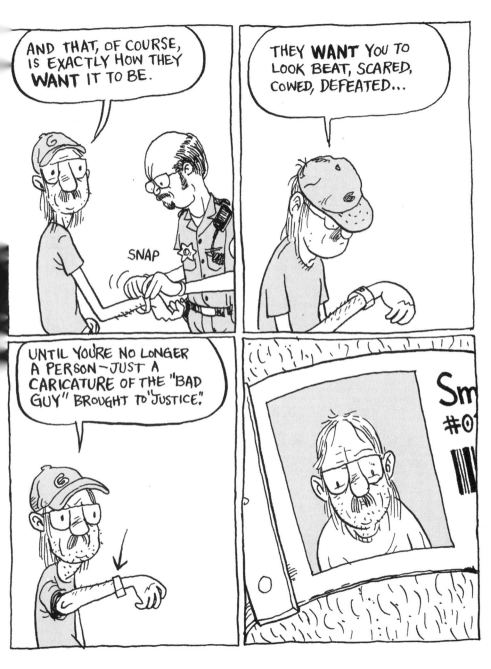

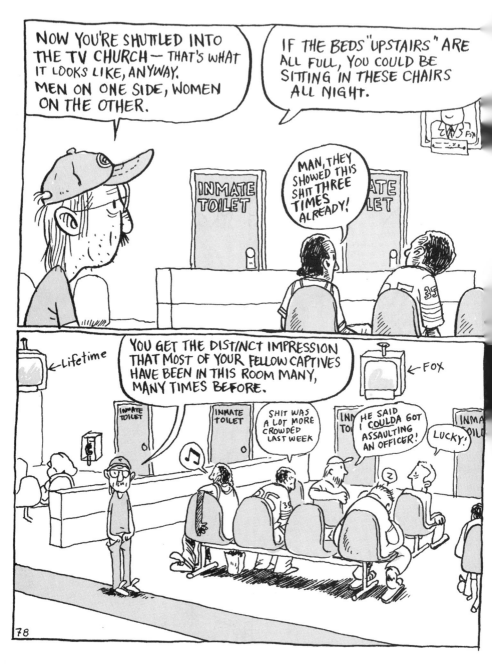

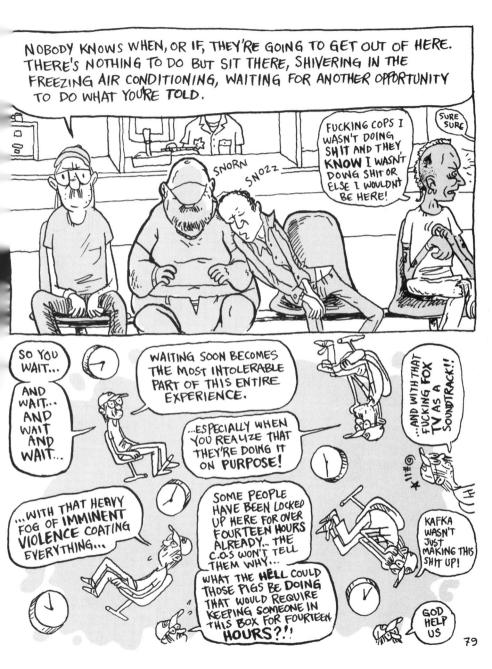

AFTER A FEW HOURS, THE STATE IS REQUIRED TO "FEED" YOU.

JACKSON, GREGORY!

AND THEY COMPLY—BEGRUDGINGLY—WITH THIS PAPER SACK.

ZZCH

WHAT?

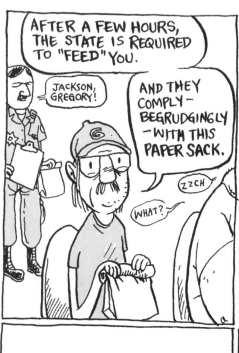

"DINNER" IS FOUR SLICES OF DYED WONDER BREAD, TWO SLICES OF VAGUELY CHEESELIKE FOOD PRODUCT,

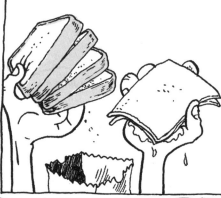

AN ORANGE, A CARTON OF 2% MILK,

2%
HAPPY DUCK

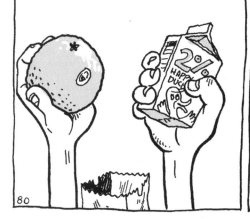

AND, ON A BARE BED OF ANONYMOUS LUNCHEON MEAT, A SINGLE GENERIC OREO-STYLE COOKIE.

F COURSE, IT'S SILLY TO OMPLAIN ABOUT FREE FOOD, HEN OTHERS HAVE MUCH MORE PPROPRIATE THINGS TO OMPLAIN ABOUT.

MAN THEY FUCKED YOU **RIGHT** UP!

WHAT I GET F' JUSS SITTIN THERE

ANYWAY, I CAN GUESS WHAT SOME OF YOU MIGHT BE THINKING AT THIS POINT〜

MY GOOD SIR...

NOBODY SAID **JAIL** WAS SUPPOSED TO BE **FUN**!

TO THIS I POSE ANOTHER QUESTION:
 WHAT THE FUCK HAPPENED TO "INNOCENT UNTIL PROVEN GUILTY"?? AND I WILL ANSWER <u>THAT</u> QUESTION BY STATING THE OBVIOUS: THAT CONCEPT IS A **NAÏVE FICTION,** DREAMED UP AND PERPETUATED **ONLY** BY THOSE FEW MEMBERS OF THIS TWISTED DYSTOPIAN SOCIETY PRIVIL-EGED ENOUGH TO HAVE **NEVER GONE TO JAIL!**

SHUT UP YO!

AND THAT MUCH SHOULD BE SADLY **SELF-EVIDENT** TO ANYONE WHO HAS SPENT SO MUCH AS A SINGLE NIGHT IN THIS WAREHOUSE FOR THE POOR.

SMALLS, GORDON!

PINK

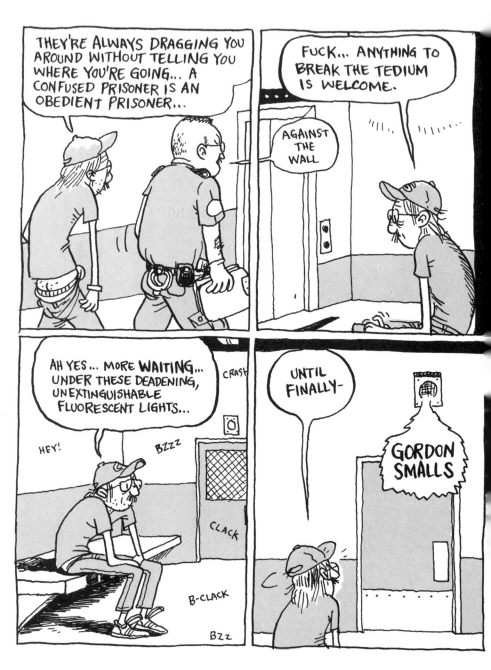

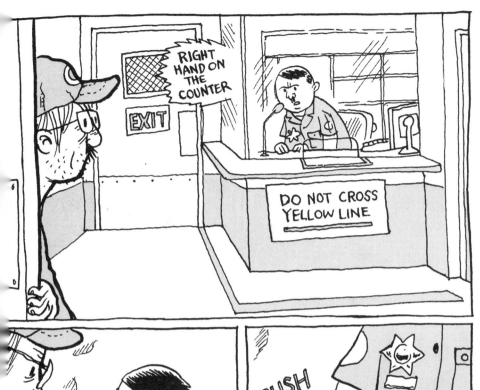

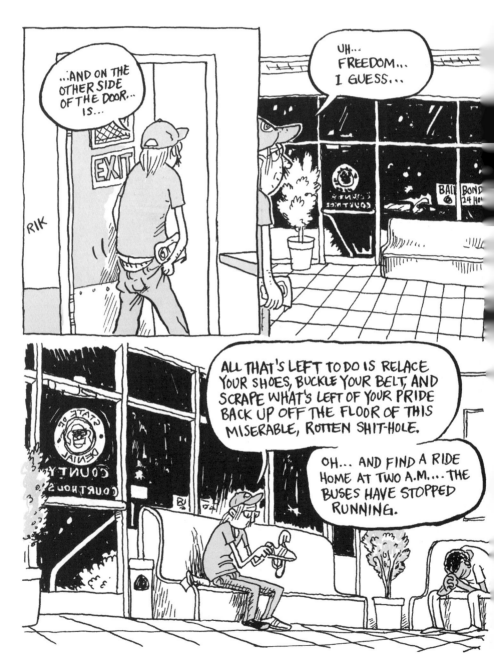

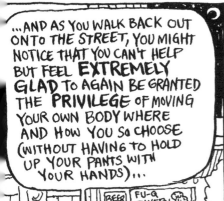

...AND AS YOU WALK BACK OUT ONTO THE STREET, YOU MIGHT NOTICE THAT YOU CAN'T HELP BUT FEEL **EXTREMELY GLAD** TO AGAIN BE GRANTED THE **PRIVILEGE** OF MOVING YOUR OWN BODY WHERE AND HOW YOU SO CHOOSE (WITHOUT HAVING TO HOLD UP YOUR PANTS WITH YOUR HANDS)...

BEER FU-Q TAVERN

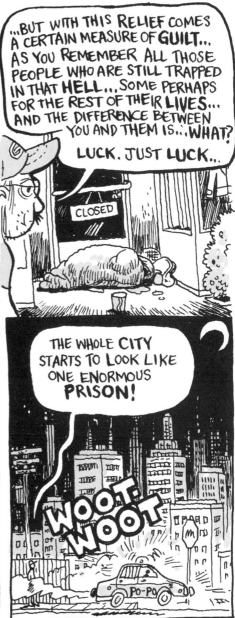

...BUT WITH THIS RELIEF COMES A CERTAIN MEASURE OF **GUILT**... AS YOU REMEMBER ALL THOSE PEOPLE WHO ARE STILL TRAPPED IN THAT **HELL**...SOME PERHAPS FOR THE REST OF THEIR **LIVES**... AND THE DIFFERENCE BETWEEN YOU AND THEM IS...WHAT?

LUCK. JUST LUCK...

CLOSED

THE WHOLE CITY STARTS TO LOOK LIKE ONE ENORMOUS **PRISON!**

WOOT- WOOT

PO-PO

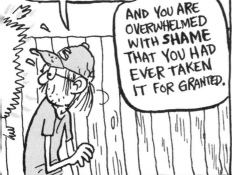

AND ALSO — PERHAPS FOR THE FIRST TIME IN YOUR SHELTERED, IGNORANT LIFE — YOU NOW ARE ACUTELY AWARE OF HOW **TENUOUS**... EVEN **ILLUSORY**...YOUR "FREEDOM" REALLY IS.

AND YOU ARE OVERWHELMED WITH **SHAME** THAT YOU HAD EVER TAKEN IT FOR GRANTED.

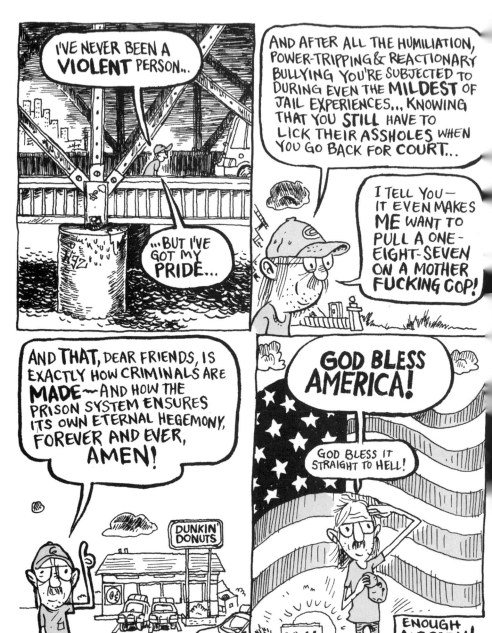

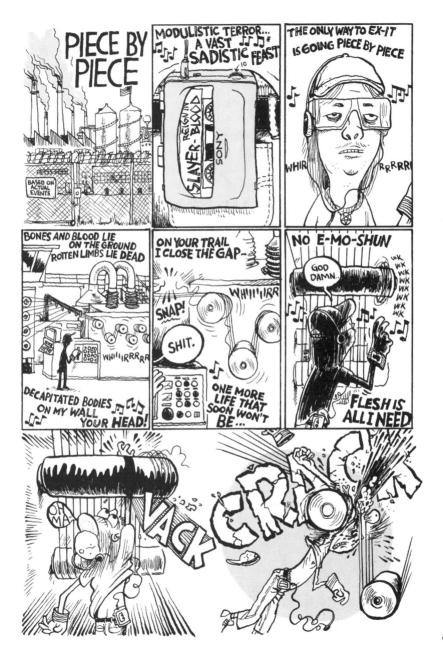

YOU HAVE NO CHOICE OF LIFE OR DEATH MY FACE YOU WILL NOT SEE

I'LL RIP YOUR FLESH 'TIL THERE'S NO BREATH DISMEMBERED DESTINY

MODULISTIC TERROR... A VAST SADISTIC FEAST... THERE'S ONLY ONE WAY OUTTA HERE

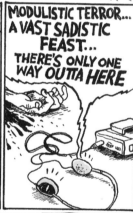

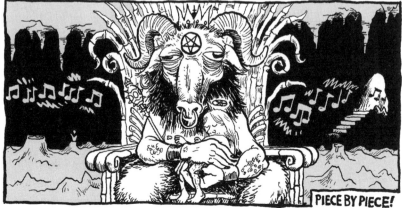

PIECE BY PIECE!

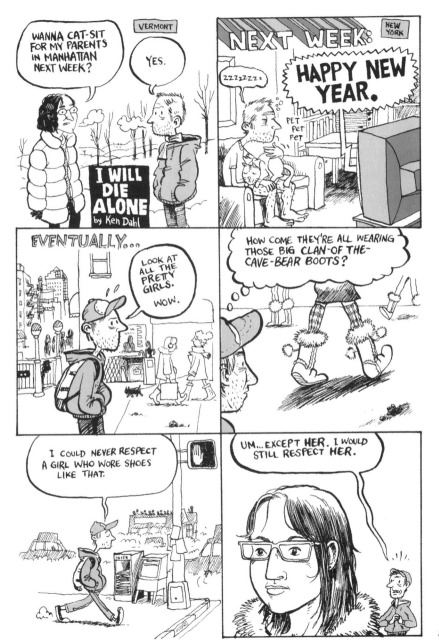

89

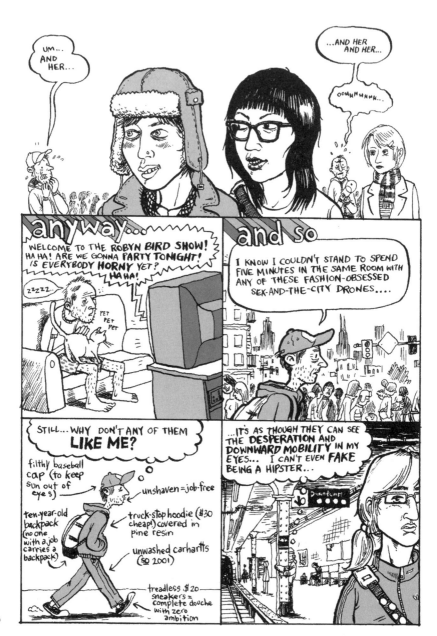

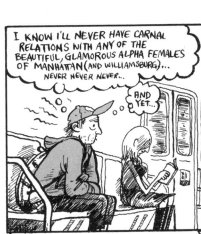

I KNOW I'LL NEVER HAVE CARNAL RELATIONS WITH ANY OF THE BEAUTIFUL, GLAMOROUS ALPHA FEMALES OF MANHATTAN (AND WILLIAMSBURG)... NEVER NEVER NEVER...

AND YET...

AND YET **WHY DO I CARE?!?**

WHY DO I EVEN **CARE** THAT MY WITHERED, DISEASED OLD COCK WILL NEVER BE SLAPPED AROUND BY ANY OF THE CONDO-LIVING, CENTRAL-PARK-JOGGING, PERFECTLY FORMED AND SOULLESS DRIADS OF THIS MYTHICAL SUPER-URBAN DYSTOPIA AT THE CENTER OF THE KNOWN UNIVERSE?

WHY IS IT SO **HARD** TO ACCEPT THE UTTER **FINALITY** OF THAT FACT? IT'S AS IF MY DNA ITSELF BEGINS TO **REBEL** AGAINST THE **CERTAINTY**... FORCING ME TO CLING TO HOPE, LIKE A MAN BEGGING FOR LIFE WHEN HE'S HALFWAY DOWN A SHARK'S THROAT... NATURAL SELECTION HAS CONDEMNED ME TO LIVE OUT MY ROLE AS JUST ANOTHER FUCK-HUNGRY MALE SCUMBAG...

WHY CAN'T I JUST BE **HAPPY**?

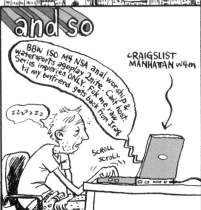

and so

BBW ISO M4 NSA anal worship & watersports ageplay 2nite. Can't host. Serios inquiries ONLY. Fuk me raw til my boyfrend gets back from Iraq

CRAIGSLIST MANHATTAN w4m

zzzzzz

SCROLL SCROLL

ISN'T THIS SOMETHING WE CAN ALL RELATE TO

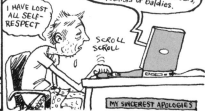

YOU CAN'T AFFORD ME w4m
Super-hot athletic intelligent 22yo art student with great ass looking for hunk to love me, pamper me, pay my rent. Must be professional, old free, well-dressed. No losers, cartoonists or baldies.

I HAVE LOST ALL SELF-RESPECT

SCROLL SCROLL

MY SINCEREST APOLOGIES

91

the full "stick"

A poem by
pers-4333████56@craigslist.org
faithfully transcribed by Ken Dahl

Speak, gentle muse!

QT worker — September 27th, 2007

you talked to me about the hot drink area

and then showed me a partial boner in your black dress pants — VERY nice for a young budd

SQUIRK

SSUCK

CREE

BAT BAT

let's try to show each other the full "stick"

SET.

92

m4W

awkwardly re-enacted by Ken Dahl

I was driving past and I saw you. You were wearing black tights, an elf hat, and some type of elf tunic thing that seemed to be saying "I've got more than cookies and milk for YOU, Santa!"

...NAMED "HYMEN DIAMOND"!

HA HA

I just wanted to say thank you for not zipping your hoodie up all the way because you have really amazing breasts and I appreciate them very much.

JESUS FUCKING CHRIST

YOU SEXY WHORE

You were obviously very proud of them, showing them off for the world to see, and rightly so.

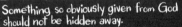

Something so obviously given from God should not be hidden away.

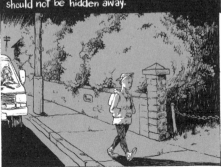

93

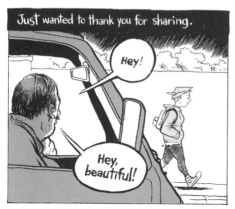

Just wanted to thank you for sharing.

Hey!

Hey, beautiful!

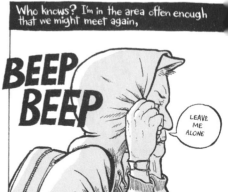

Who knows? I'm in the area often enough that we might meet again,

BEEP BEEP

LEAVE ME ALONE

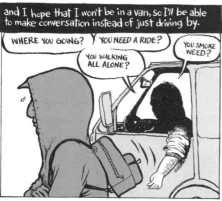

and I hope that I won't be in a van, so I'll be able to make conversation instead of just driving by.

WHERE YOU GOING?

YOU NEED A RIDE?

YOU SMOKE WEED?

YOU WALKING ALL ALONE?

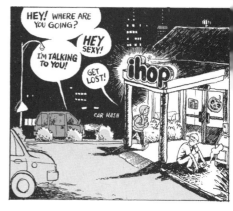

HEY! WHERE ARE YOU GOING?

HEY SEXY!

I'M TALKING TO YOU!

GET LOST!

CAR WASH

ihop

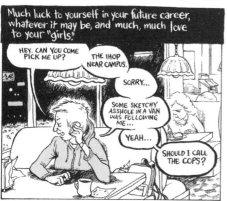

Much luck to yourself in your future career, whatever it may be, and much, much love to your "girls."

HEY. CAN YOU COME PICK ME UP?

THE IHOP NEAR CAMPUS.

SORRY...

SOME SKETCHY ASSHOLE IN A VAN WAS FOLLOWING ME...

YEAH...

SHOULD I CALL THE COPS?

Will I get to see you (and them) at Christmas?

HEH

>SEND<

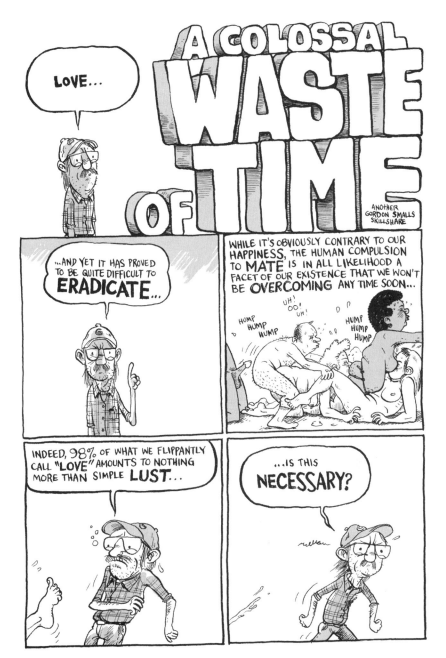

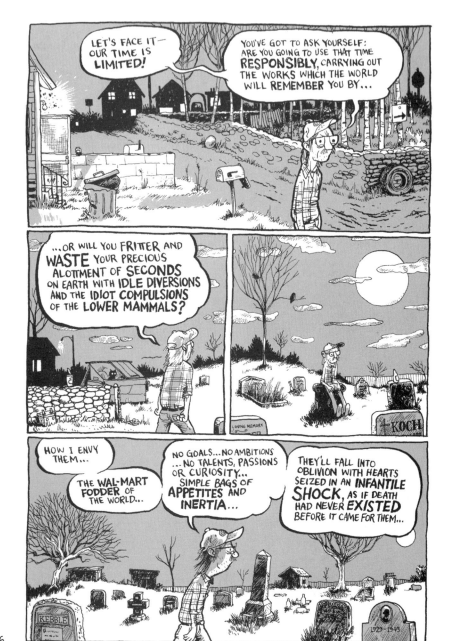

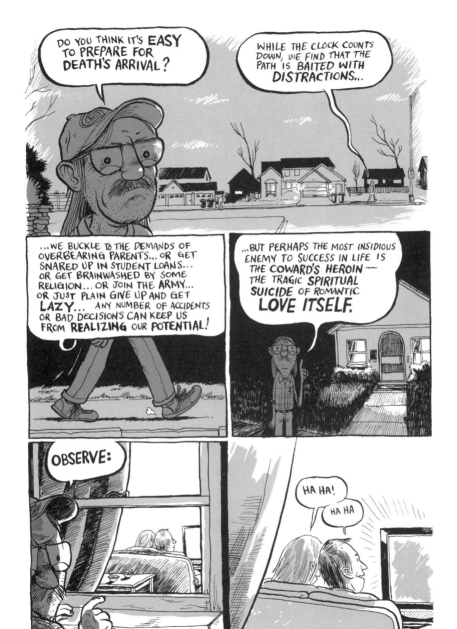

THIS "COUPLE" SITS IN FRONT OF THAT SOUL-SUCKING TV SET FOR **HOURS**, NIGHT AFTER NIGHT, **OBLIVIOUS** TO THE TIME THAT THEY'RE **FLUSHING DOWN THE TOILET** WITH THEIR VACUOUS POSTMODERN ...**NESTING INSTINCTS**...

THEY'RE CONTENT TO PLAY THEIR LITTLE "**DVDs**" AND EAT **ICE CREAM** AS THE WORLD **DROWNS** IN **POISON** RIGHT OUTSIDE THEIR QUAINT SUBURBAN DOOR...

THEY'RE CONTENT TO LET THEMSELVES DEGENERATE INTO DULL-EYED **MANATEES**, GRAZING THROUGH THE MURKY SHALLOWS OF **CODEPENDENCE**...

LATER THEY'LL JUST **FUCK** AND FALL ASLEEP... ANOTHER DAY CLOSER TO **DEATH**...

...UNTIL ONE DAY THEY FIND THEMSELVES **DRAINED** OF THE VERY **VIGOR** AND **SPARK** THAT ATTRACTED THEM TO EACH OTHER IN THE **FIRST PLACE**...

...AND THE CYCLE STARTS OVER AGAIN, WITH NOTHING TO SHOW FOR YOUR EFFORTS BUT TWENTY EXTRA POUNDS AND A LITTLE MORE **PSYCHIC DAMAGE**.

I THINK YOUR EX-BOYFRIEND IS IN MY YARD.

WHAT?

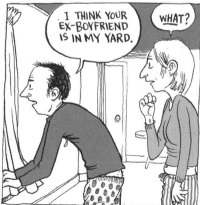

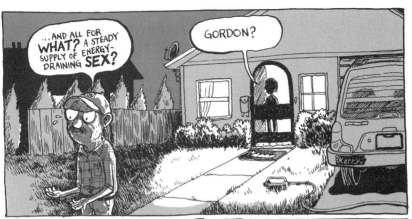

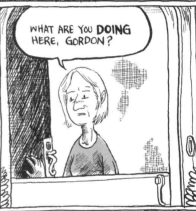

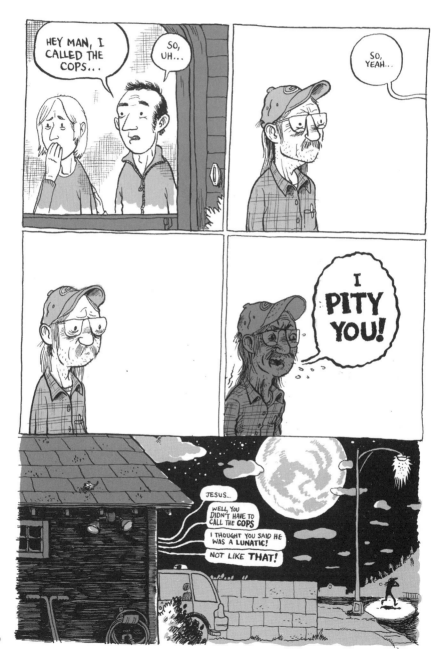

WEE-OO WEE-OO

·.SOB·.

IT HELPS, IN TIMES OF SELF-DOUBT, TO FOCUS ON THE **NEGATIVE**...

THE DISEASES... THE SLUGGISH CODEPENDENCE... THE LOGISTICAL **CERTAINTY** THAT **ANY** AND **ALL** ROMANTIC ENDEAVORS ARE DESTINED TO END IN **TRAGEDY** AND **PAIN** FOR AT LEAST **ONE** OF THE PARTICIPANTS...

ANYTHING TO MAKE IT EASIER TO CHOKE DOWN THAT SENSATION OF **INVISIBILITY**...

BARK BARK

IT'S LIKE YOU HAVE TO BE **FORGOTTEN** IN ORDER TO BE **REMEMBERED!**

NO SOLICITORS

SLAP

Can you "choke down" a SENSATION?

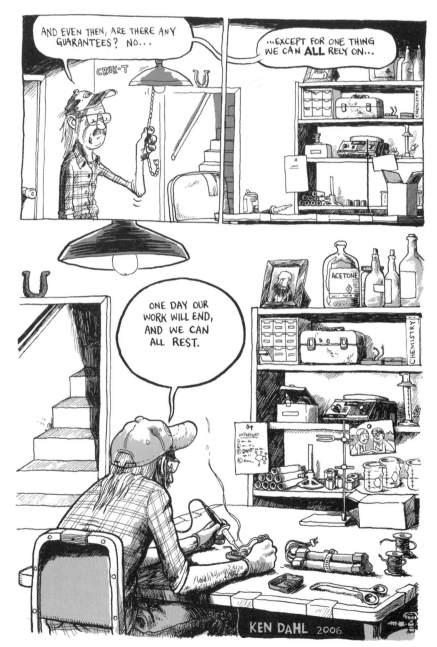

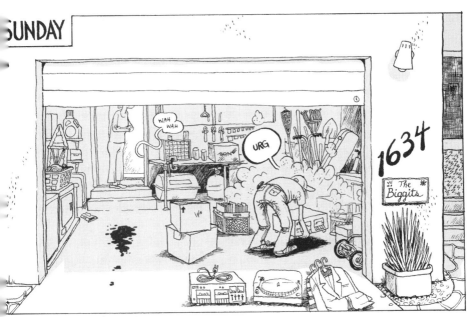

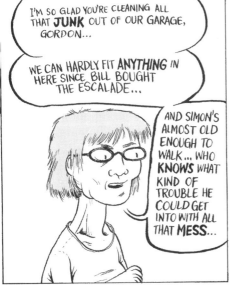

I'M SO GLAD YOU'RE CLEANING ALL THAT **JUNK** OUT OF OUR GARAGE, GORDON...

WE CAN HARDLY FIT **ANYTHING** IN HERE SINCE BILL BOUGHT THE ESCALADE...

AND SIMON'S ALMOST OLD ENOUGH TO WALK... WHO **KNOWS** WHAT KIND OF TROUBLE HE COULD GET INTO WITH ALL THAT **MESS**...

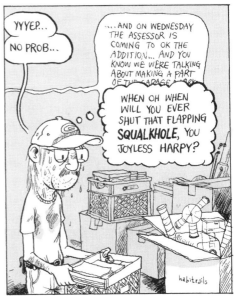

YYYEP...

NO PROB...

...AND ON WEDNESDAY THE ASSESSOR IS COMING TO OK THE ADDITION... AND YOU KNOW WE WERE TALKING ABOUT MAKING A PART OF THE GARAGE A...

WHEN OH WHEN WILL YOU EVER SHUT THAT FLAPPING **SQUALKHOLE**, YOU JOYLESS HARPY?

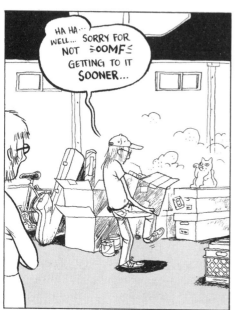

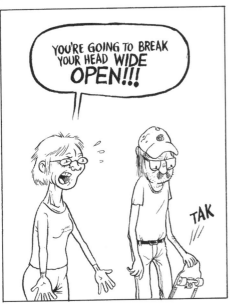

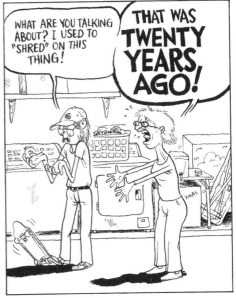

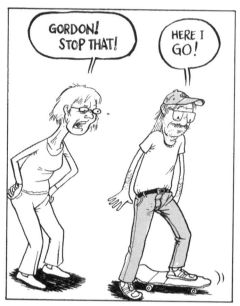

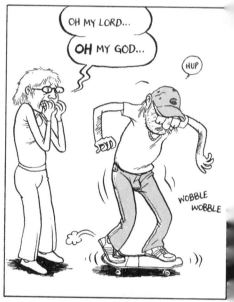

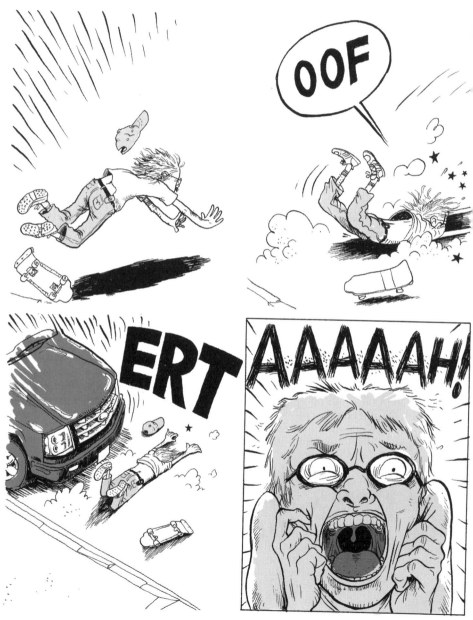

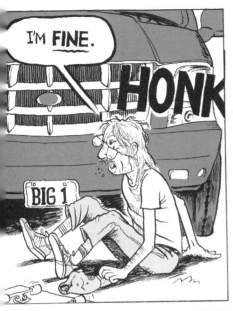

AH... NOT A CHILD IN SIGHT!

JUUUUU PUSH

KKRRRR

THERE'S SOMETHING VAGUELY **STERILE** ABOUT THESE FANCY NEW "SKATE PARKS"... THEY MUST BREED OBEDIENCE IN THE YOUTH.

NO COPS... NO SECURITY GUARDS... NO ANGRY MOTORISTS OR NOSY NEIGHBORS OR SCARY OLD DRUNKS...

...ALL ON THE UP&UP...

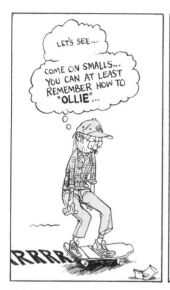

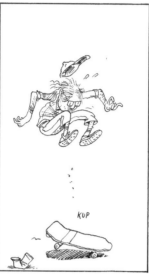

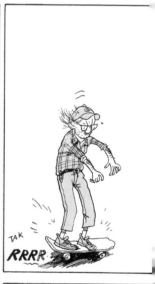

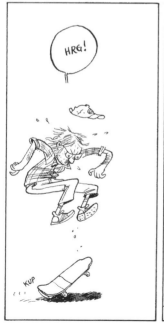

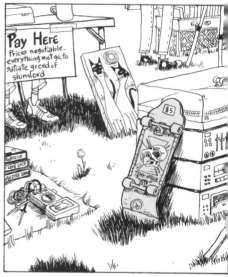

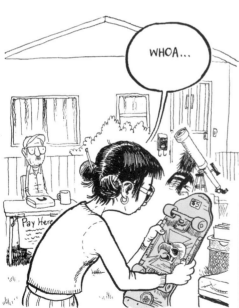

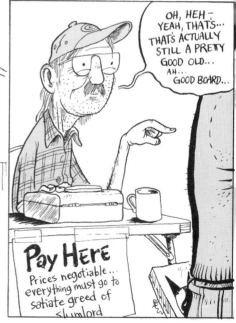

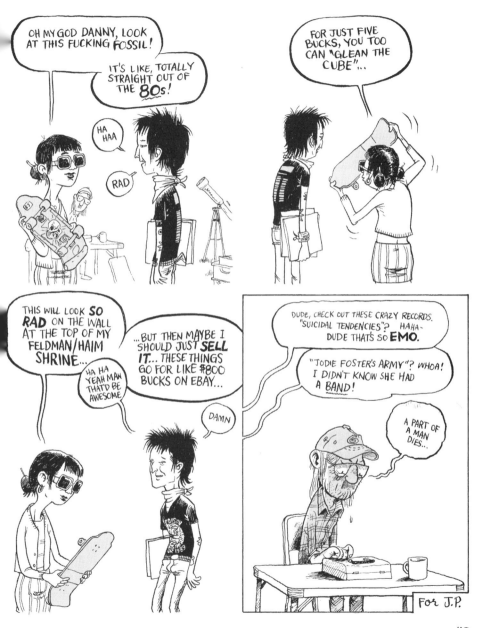

For J.P.

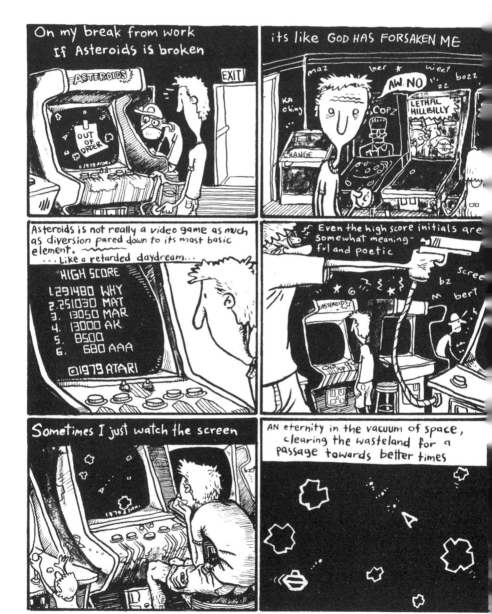

Thank you, friend.

About the Author

Ken Dahl is the nom-de-cartoon of Gabby Schulz, a rather nondescript single white male born & raised in Honolulu, Hawaii. He was the 2006-2007 Fellow at the Center for Cartoon Studies; now he is just another homeless, jobless bum hurtling toward middle age with no assets, investments, or marketable skills. His Ignatz Award-winning graphic novel about STDs, Monsters, will be published in the Fall of 2009 by Secret Acres (www.secretacres.com).

The author encourages correspondence from any cartoonist-in-residency programs, grant-giving foundations, political asylum-offering foreign embassies, and regular folk just like you. Contact him digitally at fantods@gmail.com.